ON KALEIDOSCOPE
High Contrast Kaleidoscopic Photos for Coloring

ERIKA S. CLARK

This Book is Dedicated to:

My children: Katherine, Cyrus and Alexandria for being cut from a different cloth like their parents; the coloring cadets who enjoy bringing brightness to the world; all the colorblind public who can enjoy this book as is; and to all those who have purchased it. Much gratitude to all of you. Keep on coloring. You are awesome!

Copyright © 2012 Erika S. Clark

All rights reserved.

ISBN: 1535363487
ISBN-13: 978-1535363488

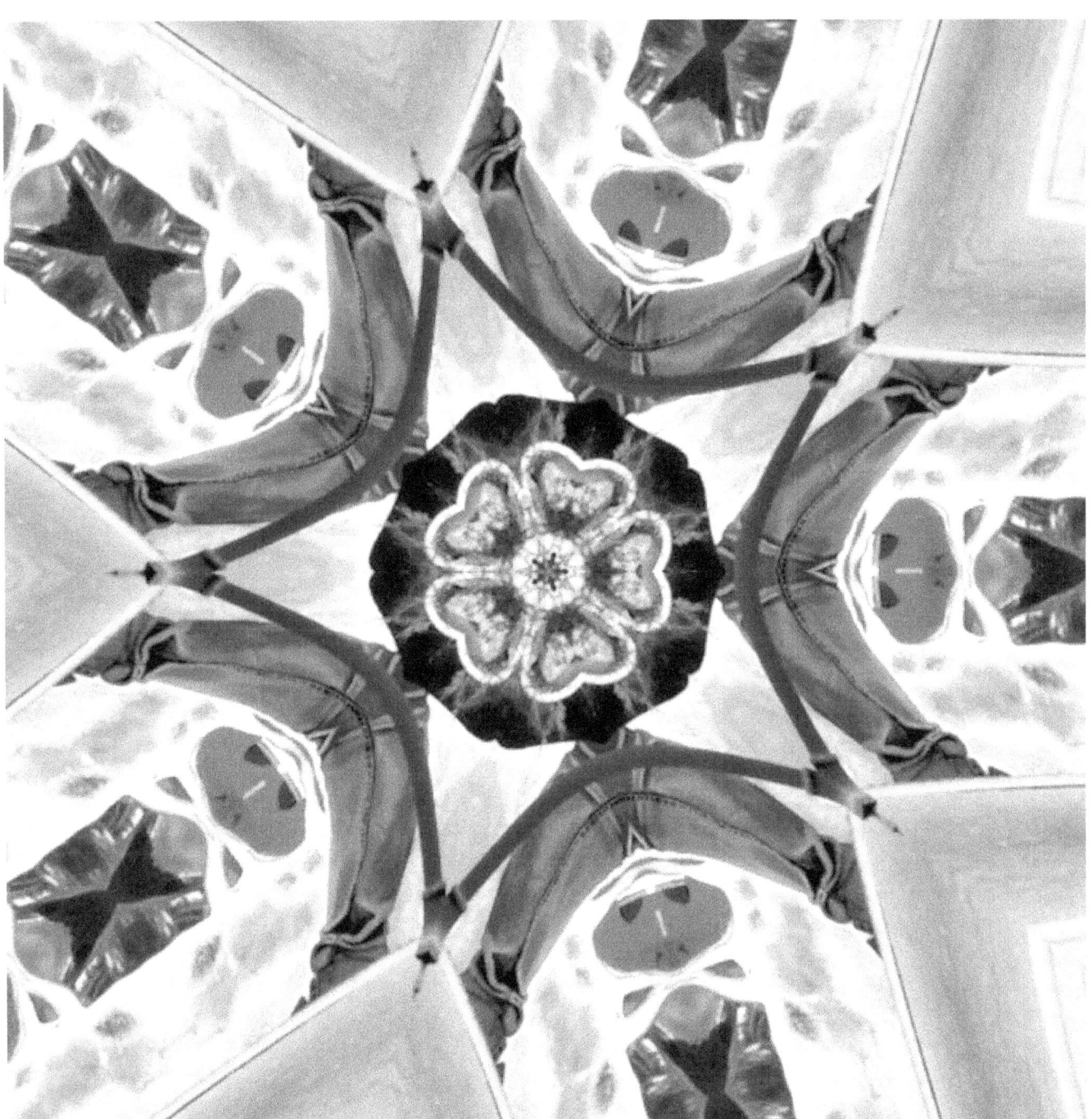

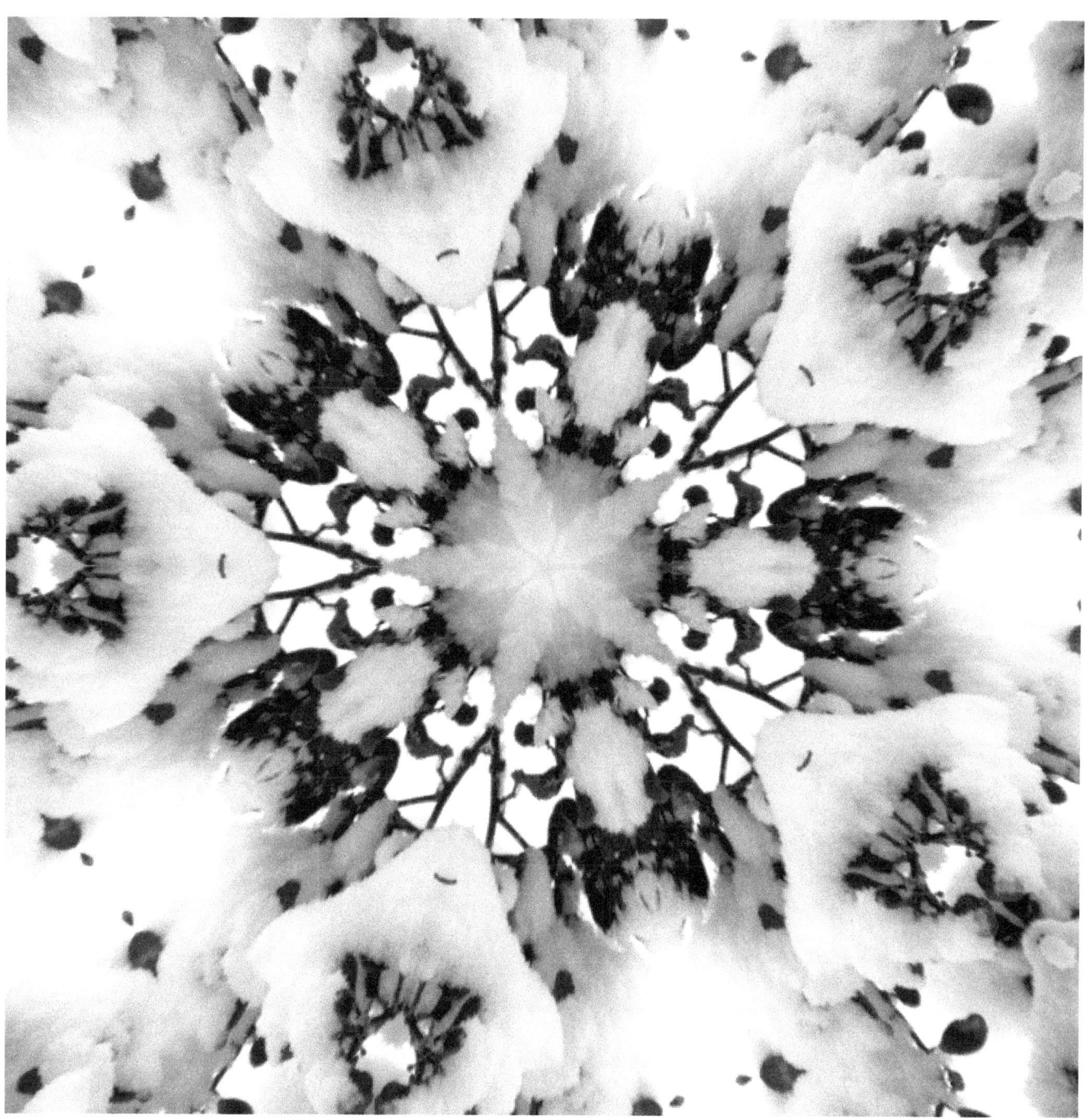

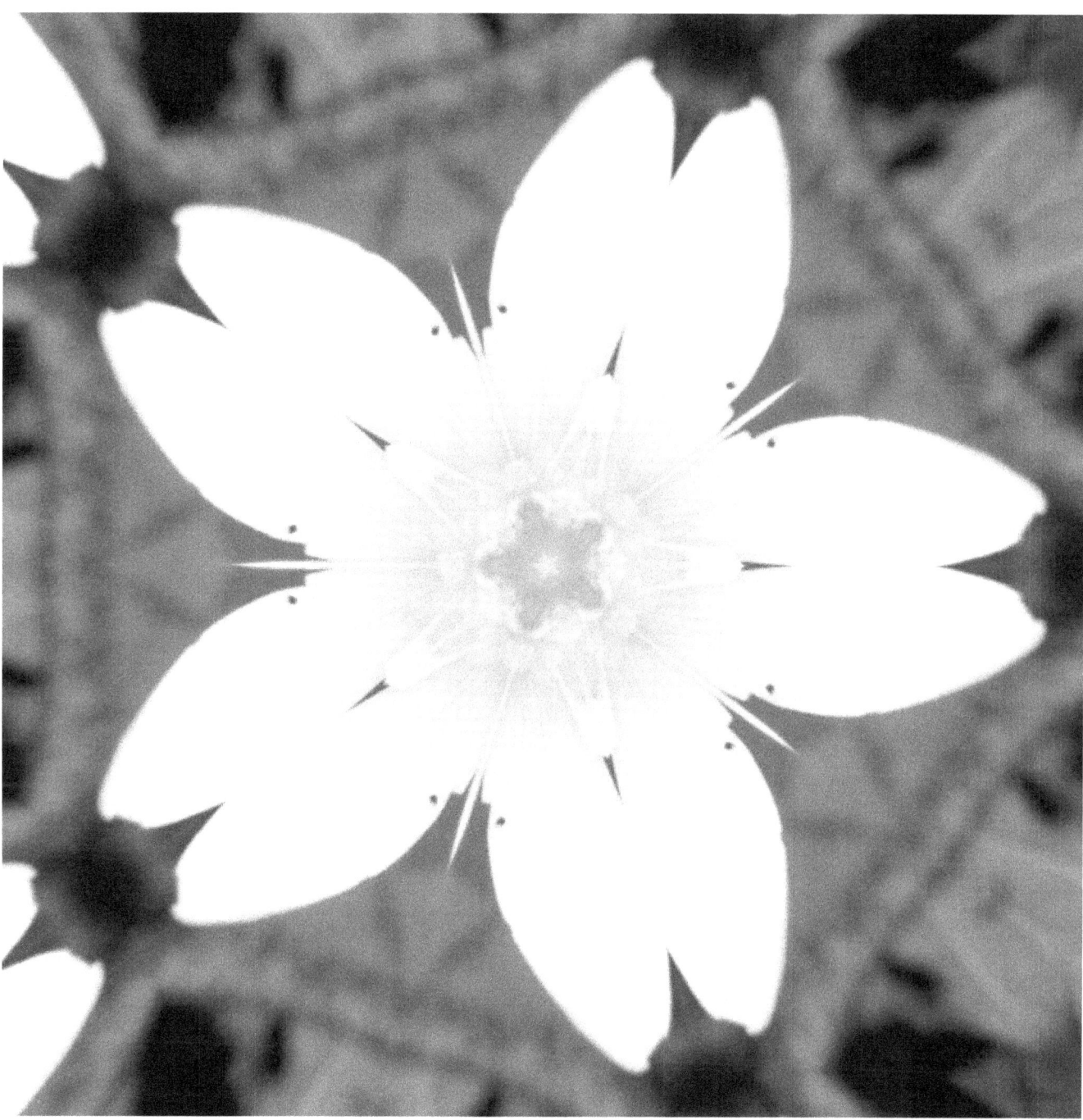

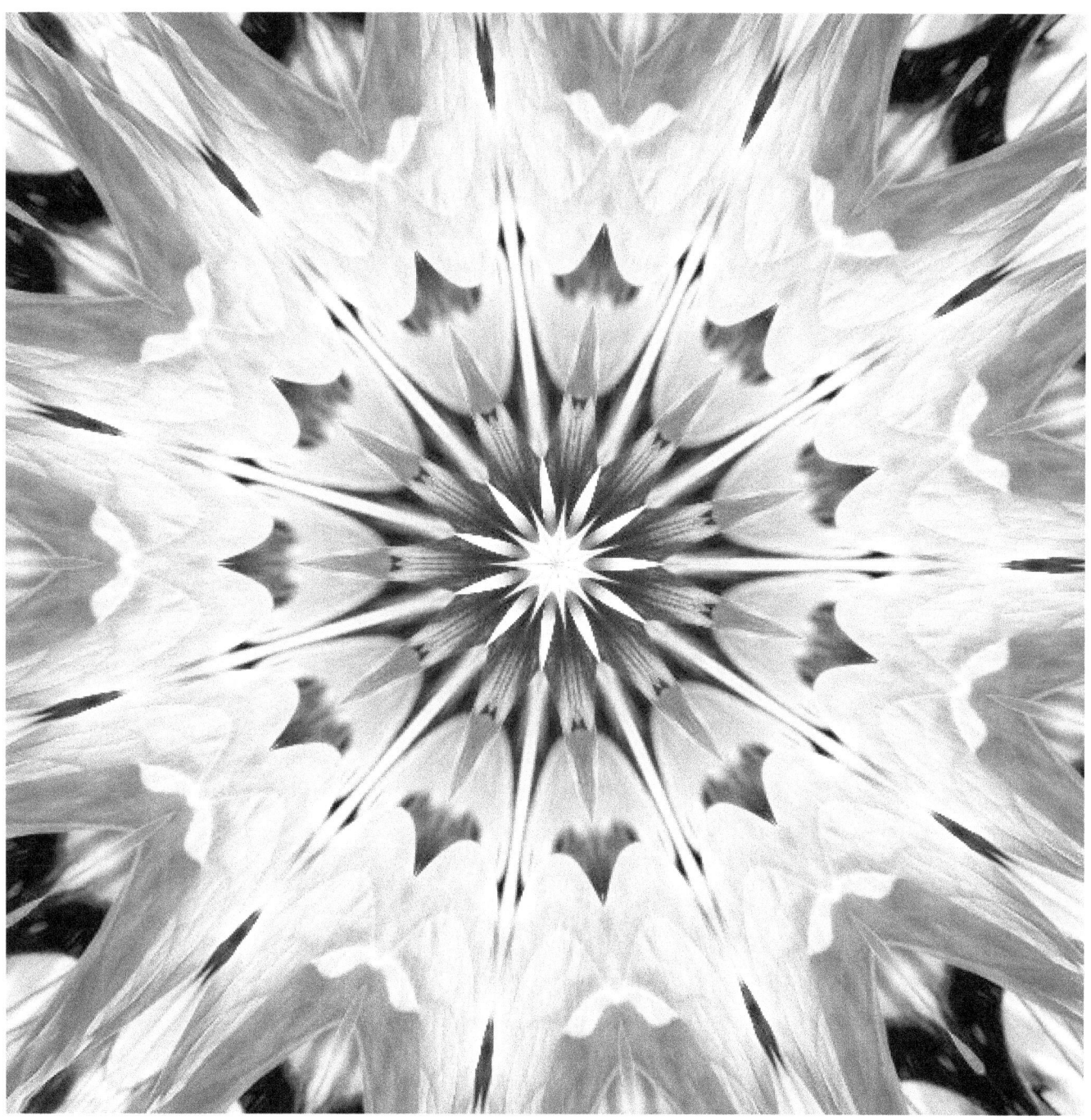

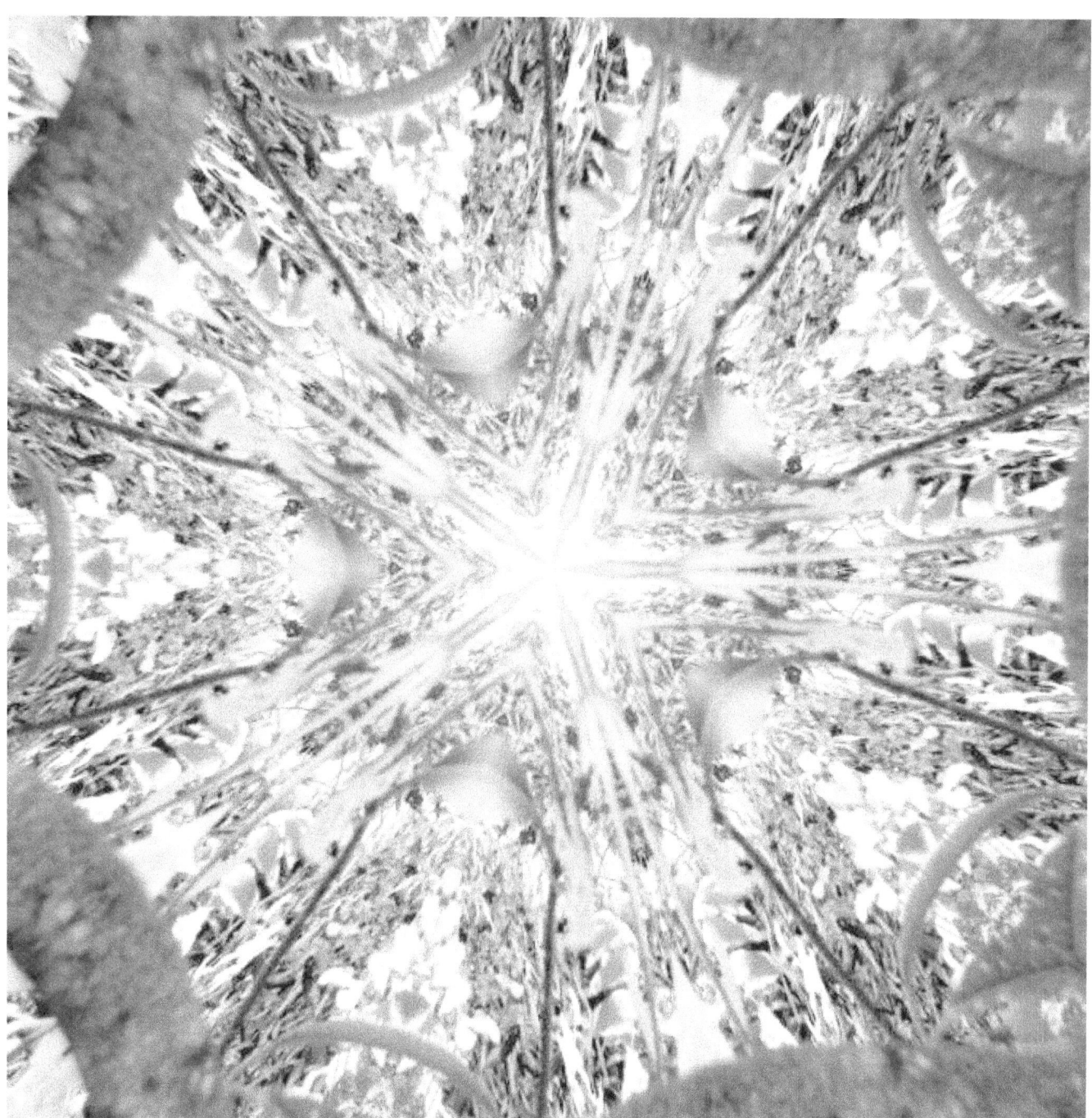

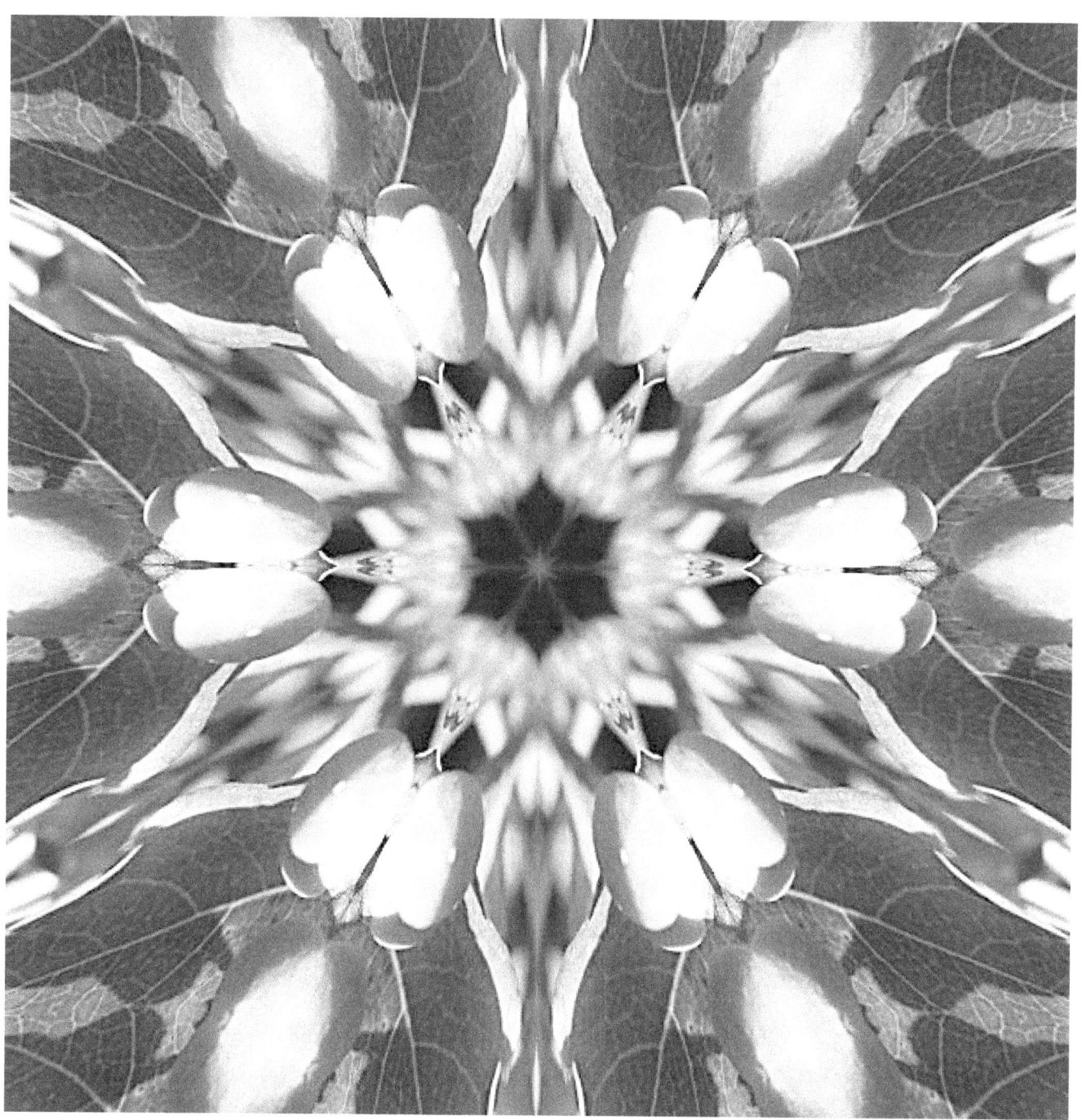

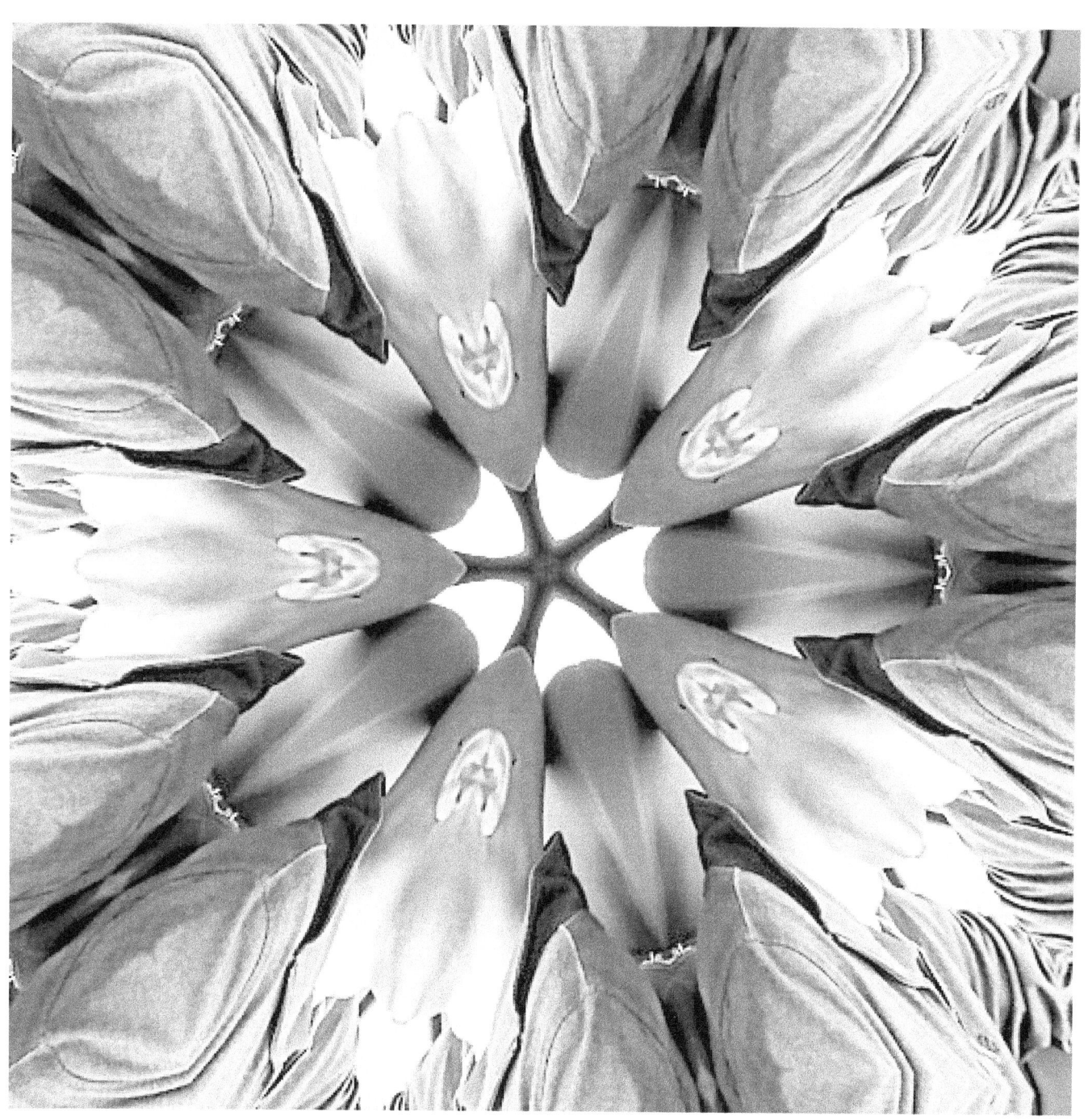

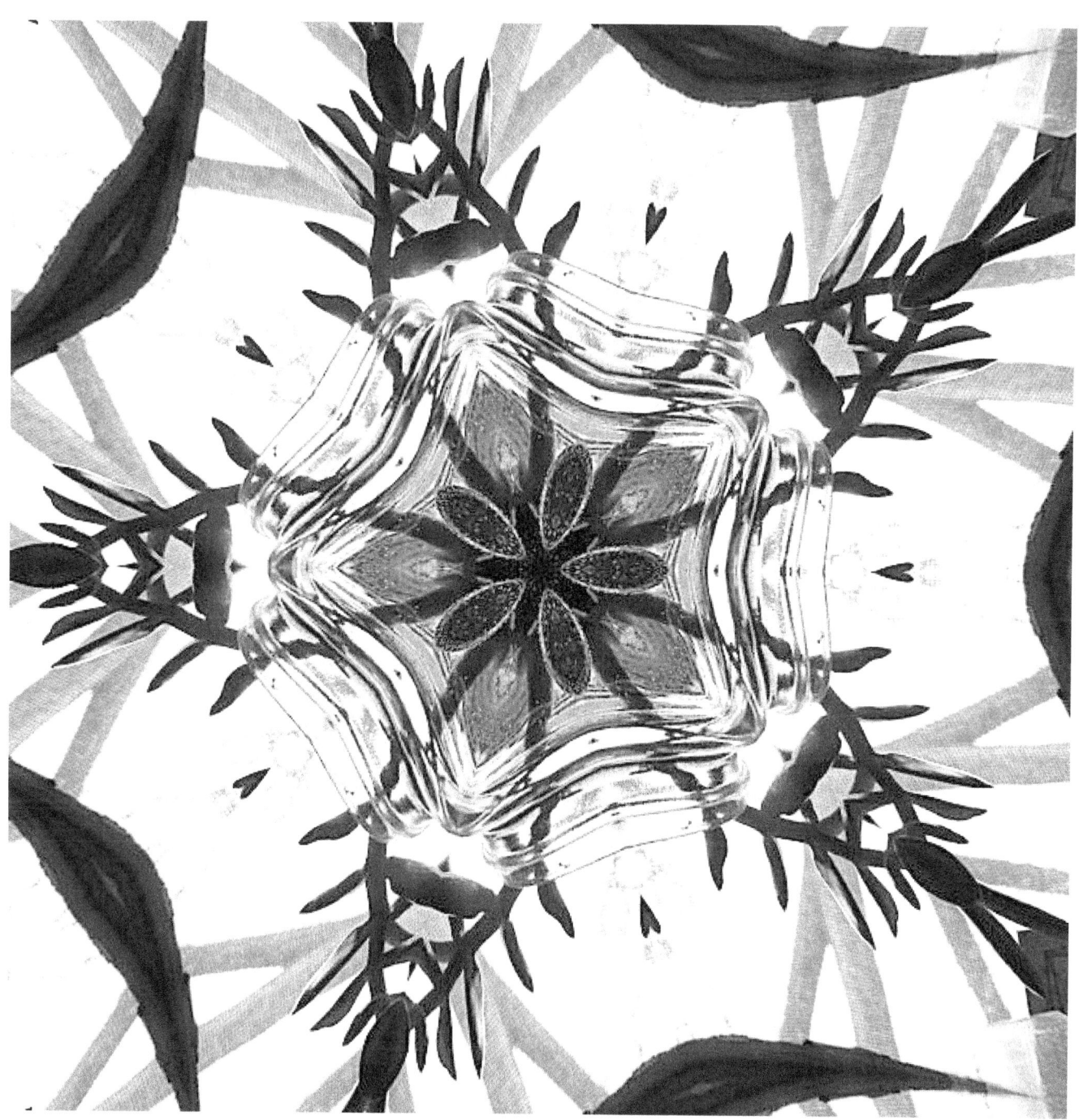

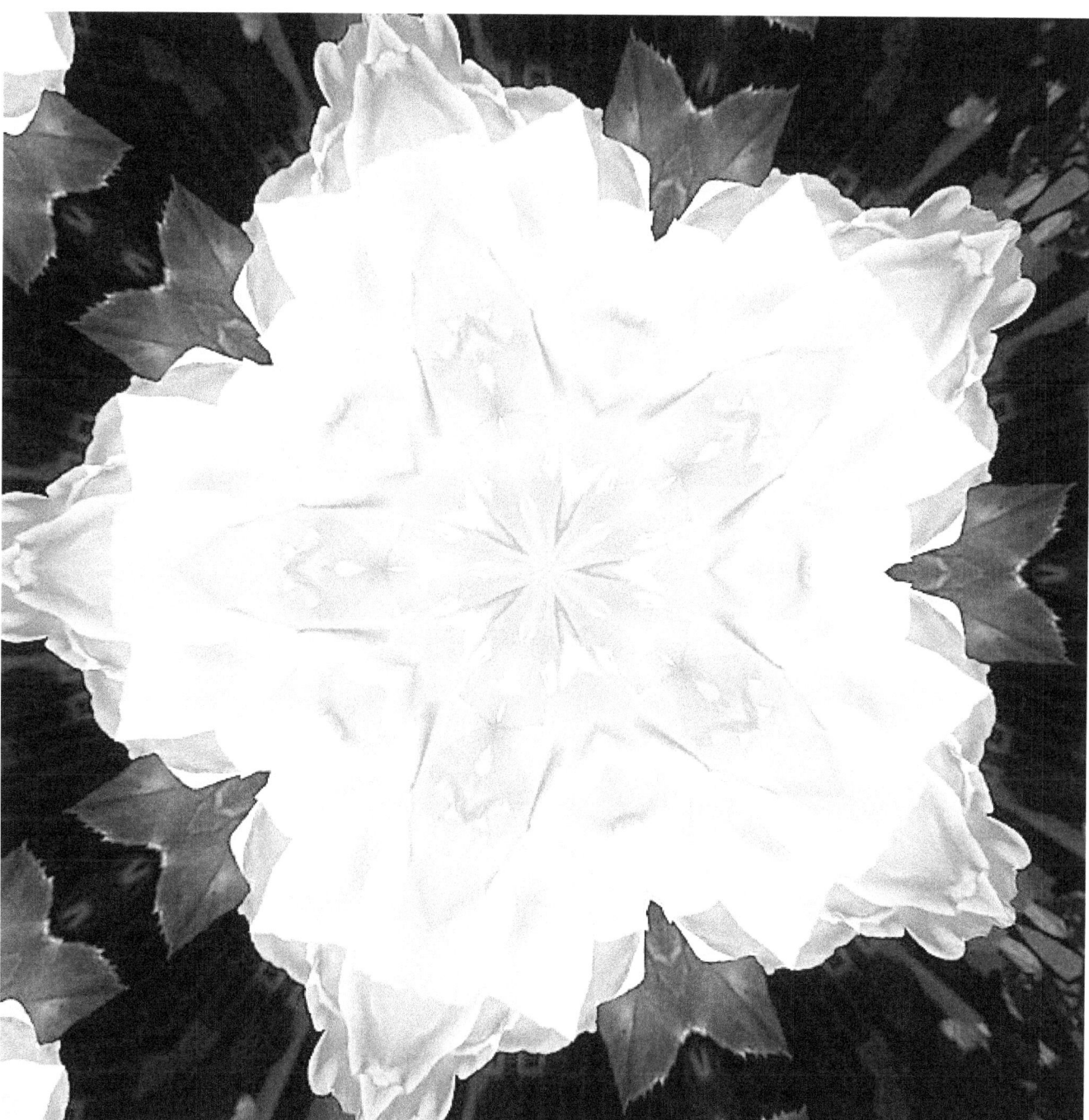

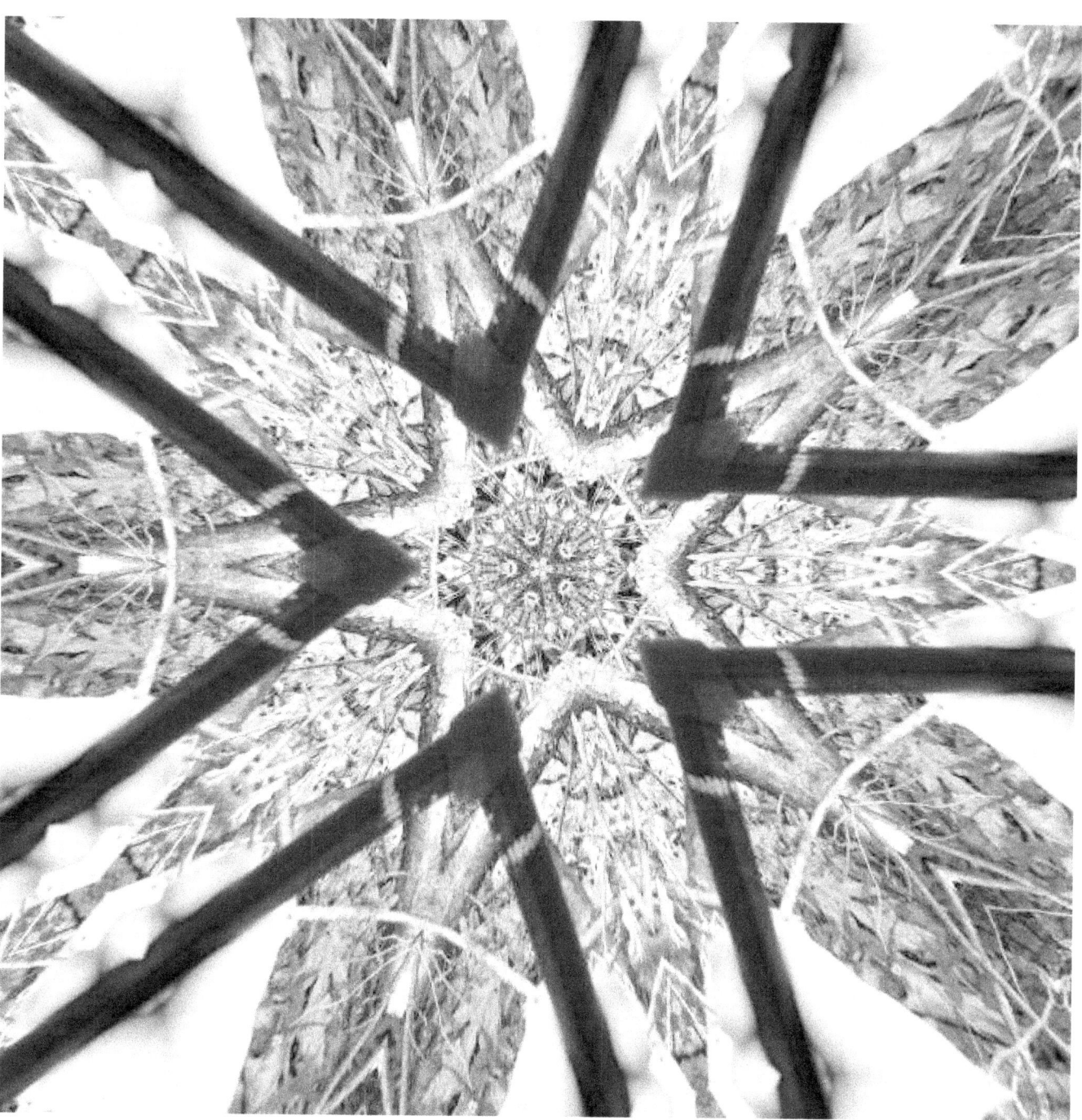

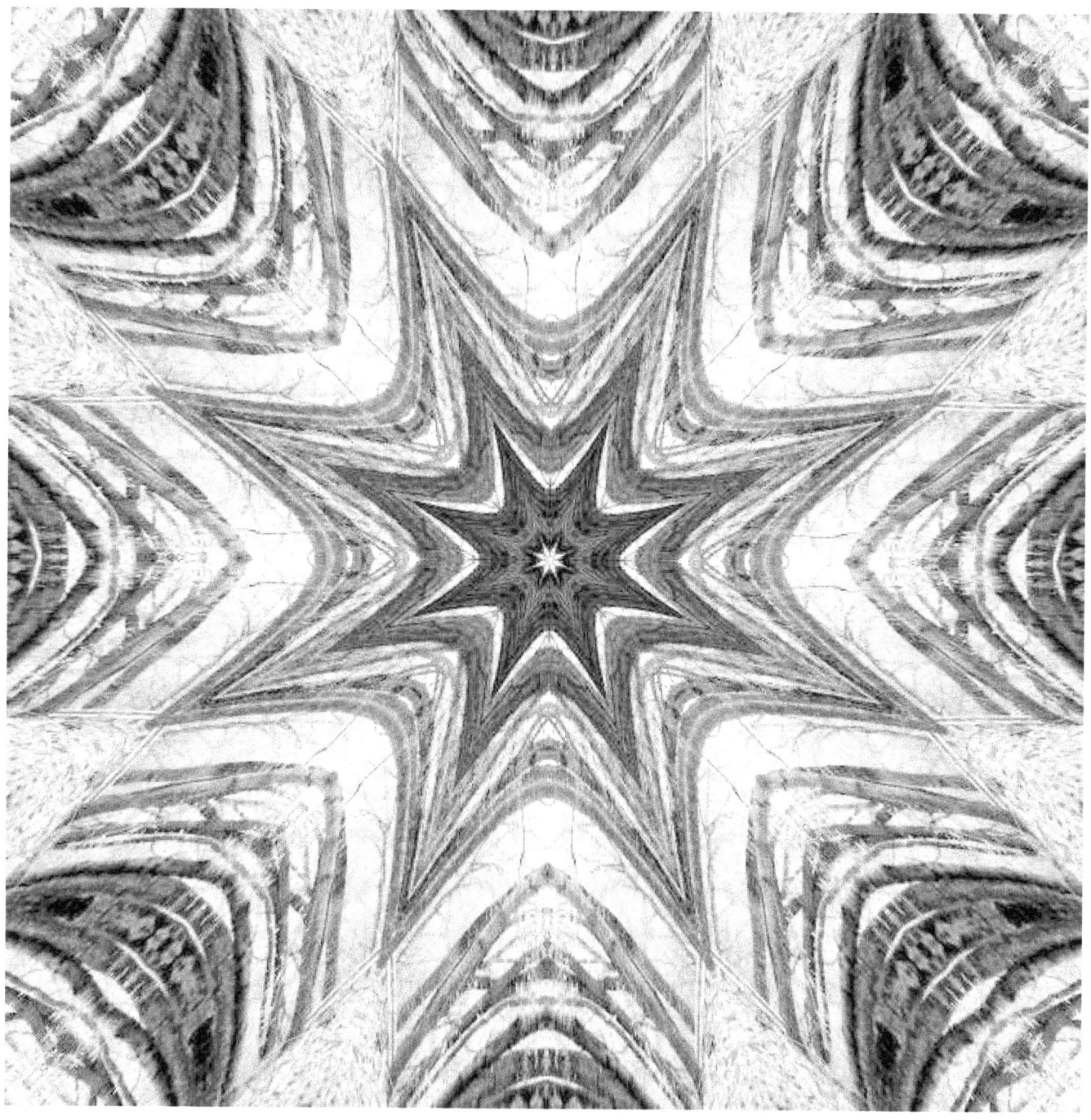

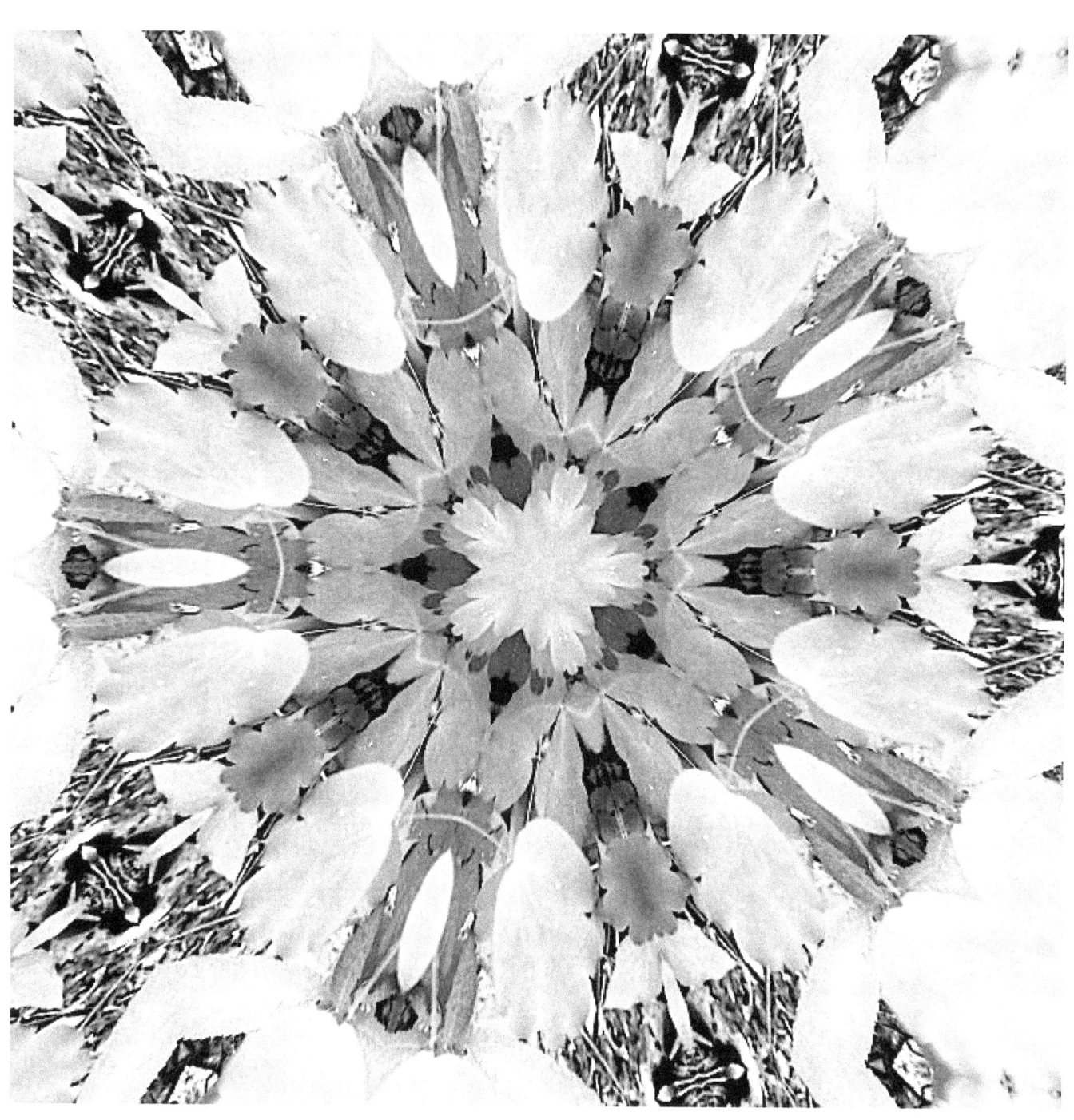

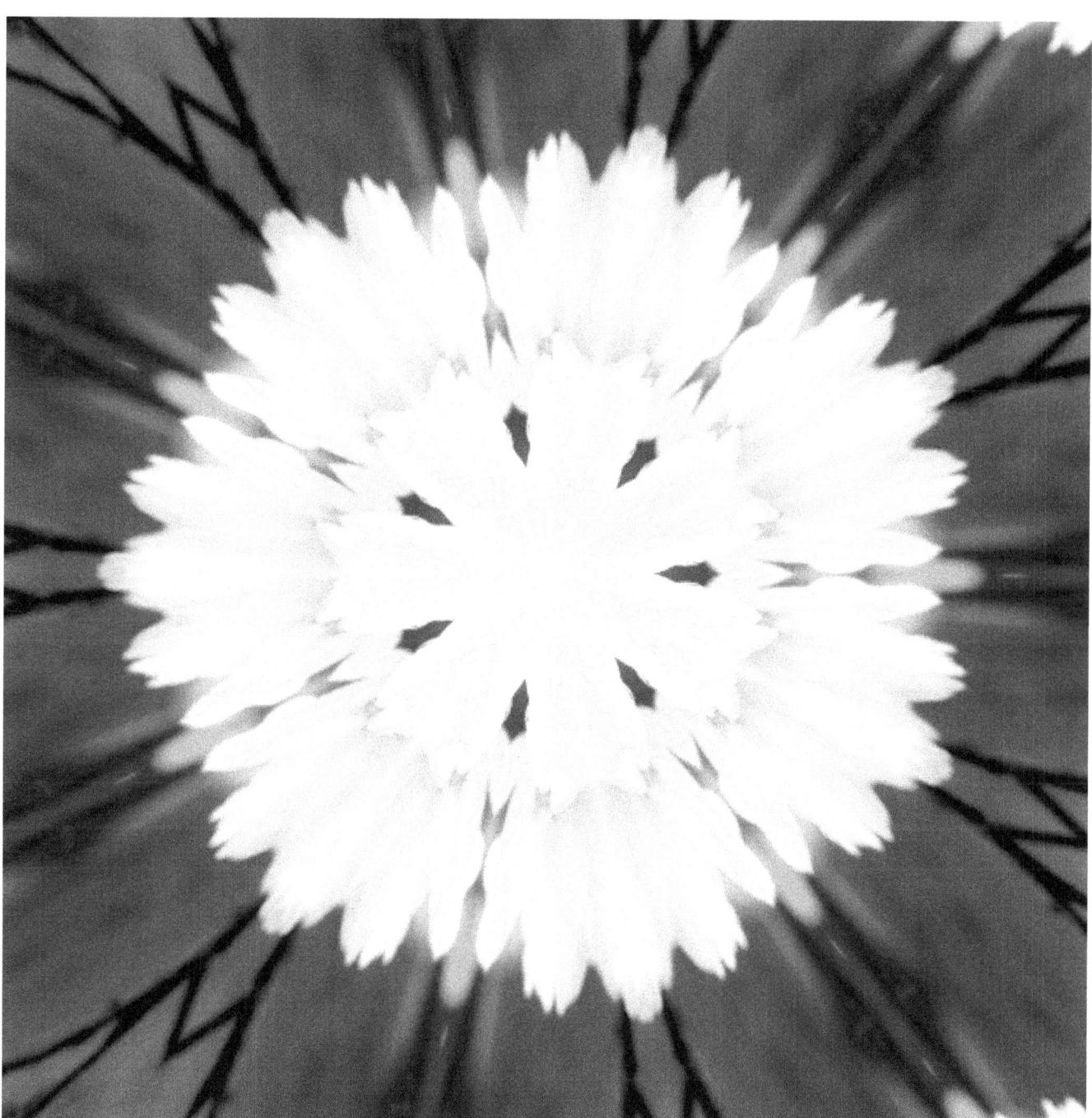

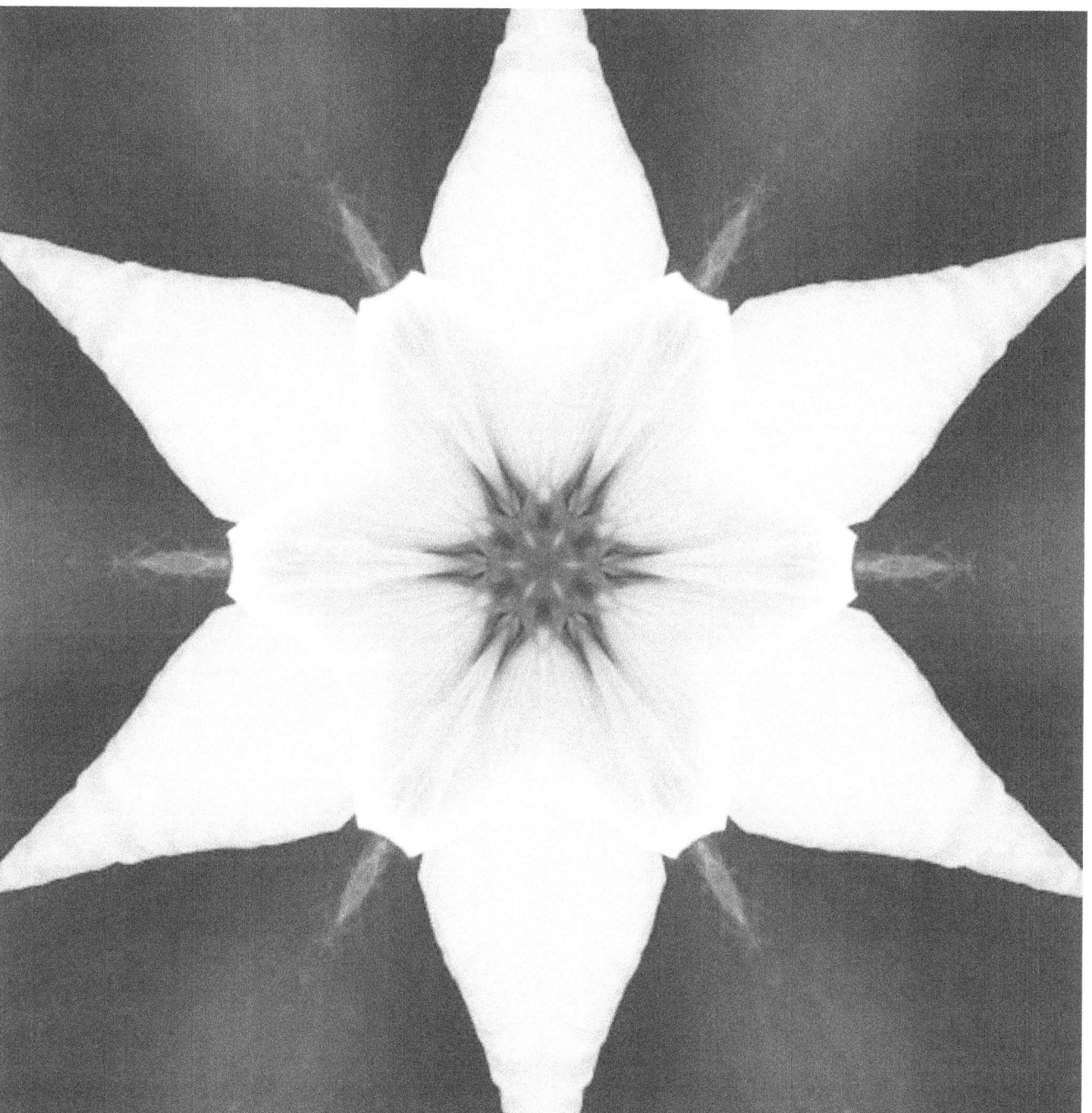

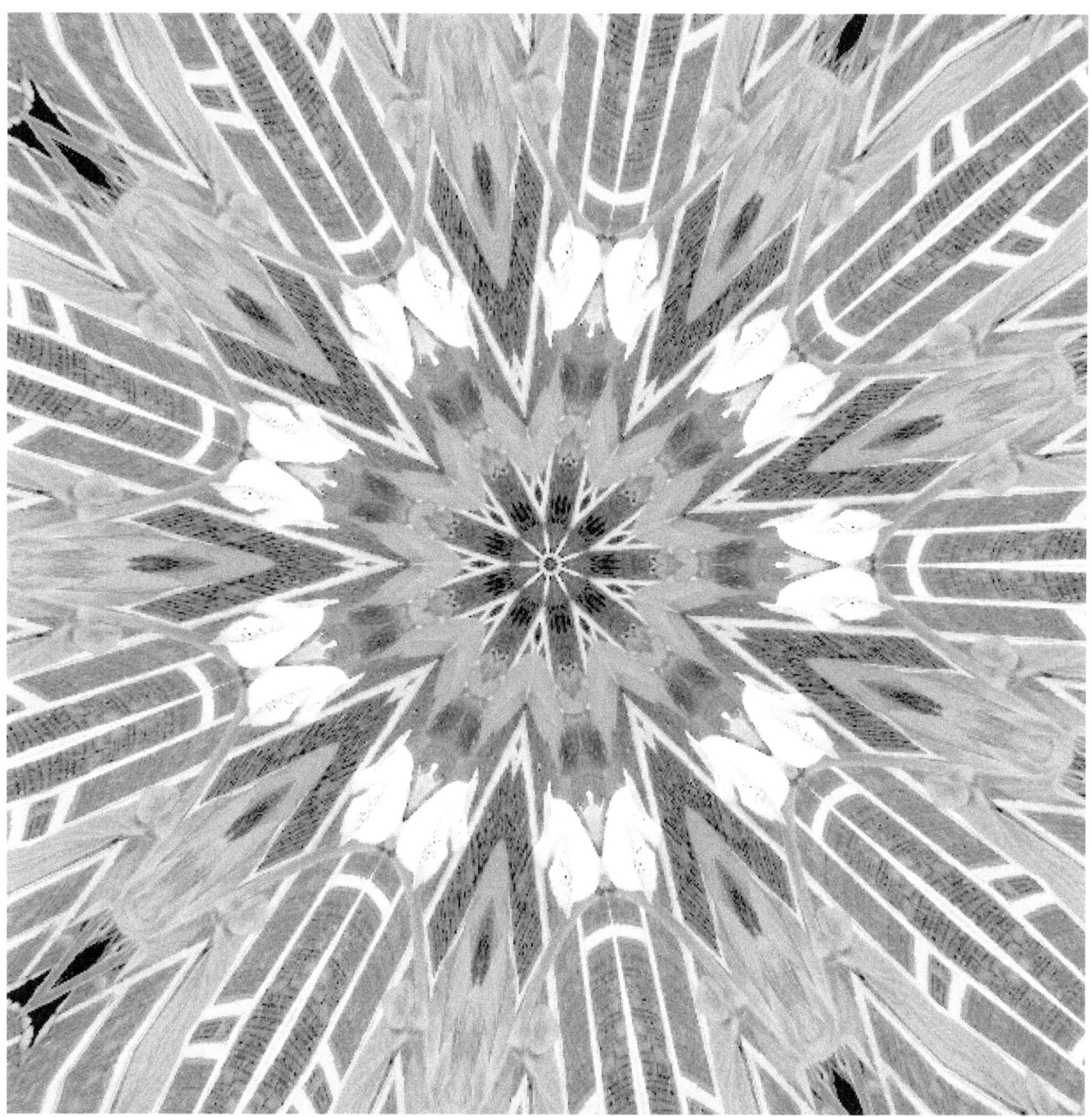

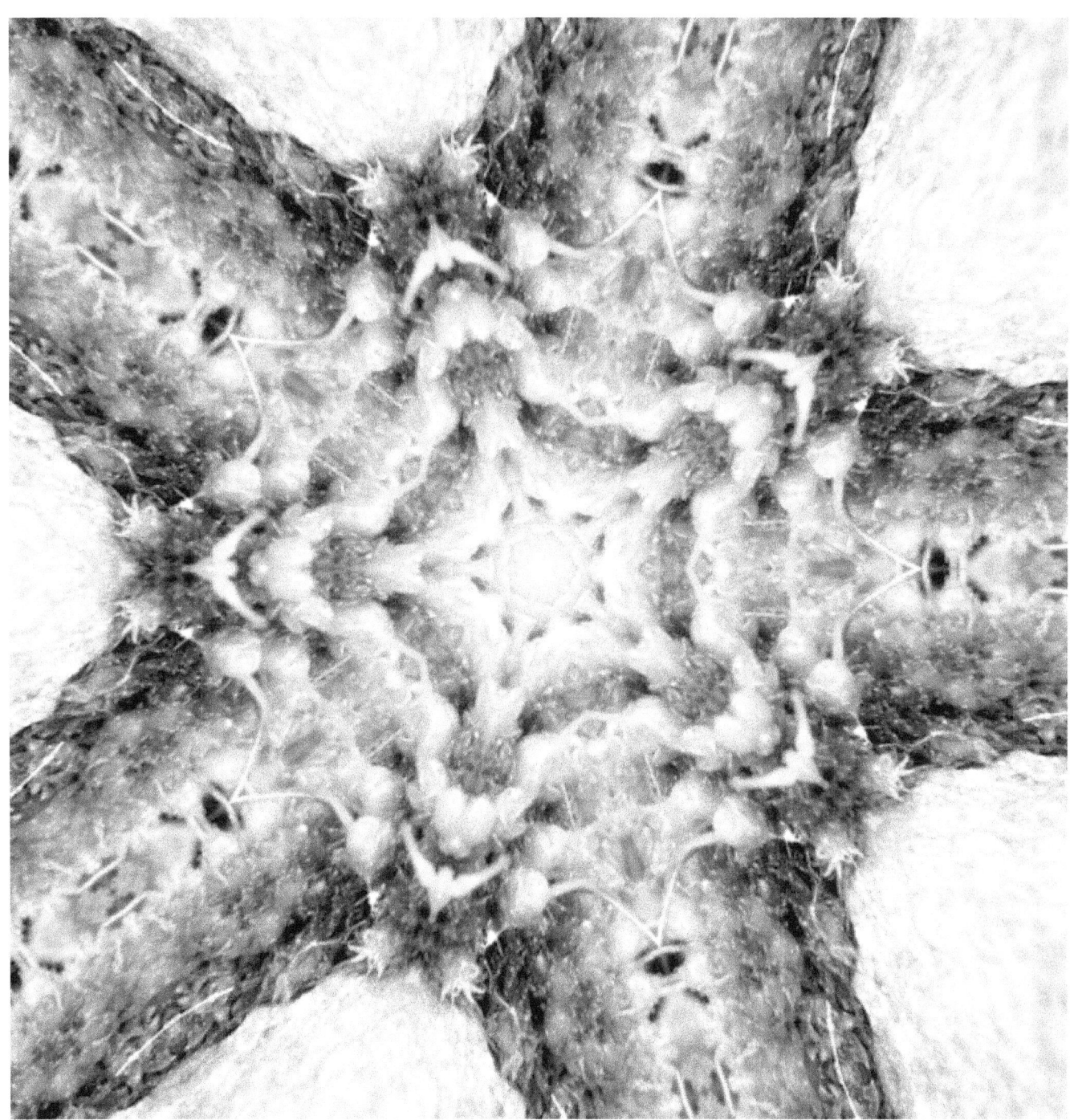

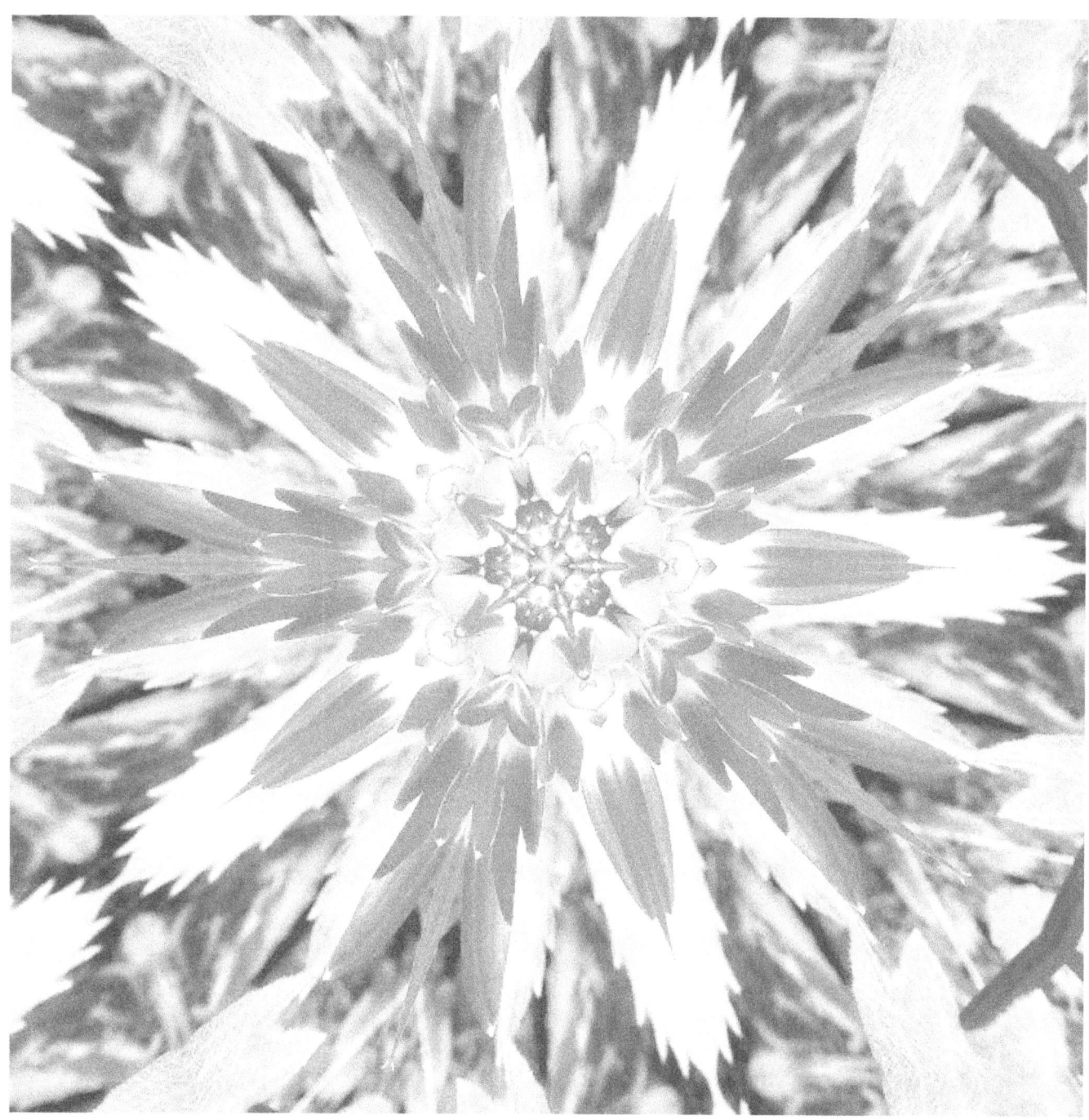

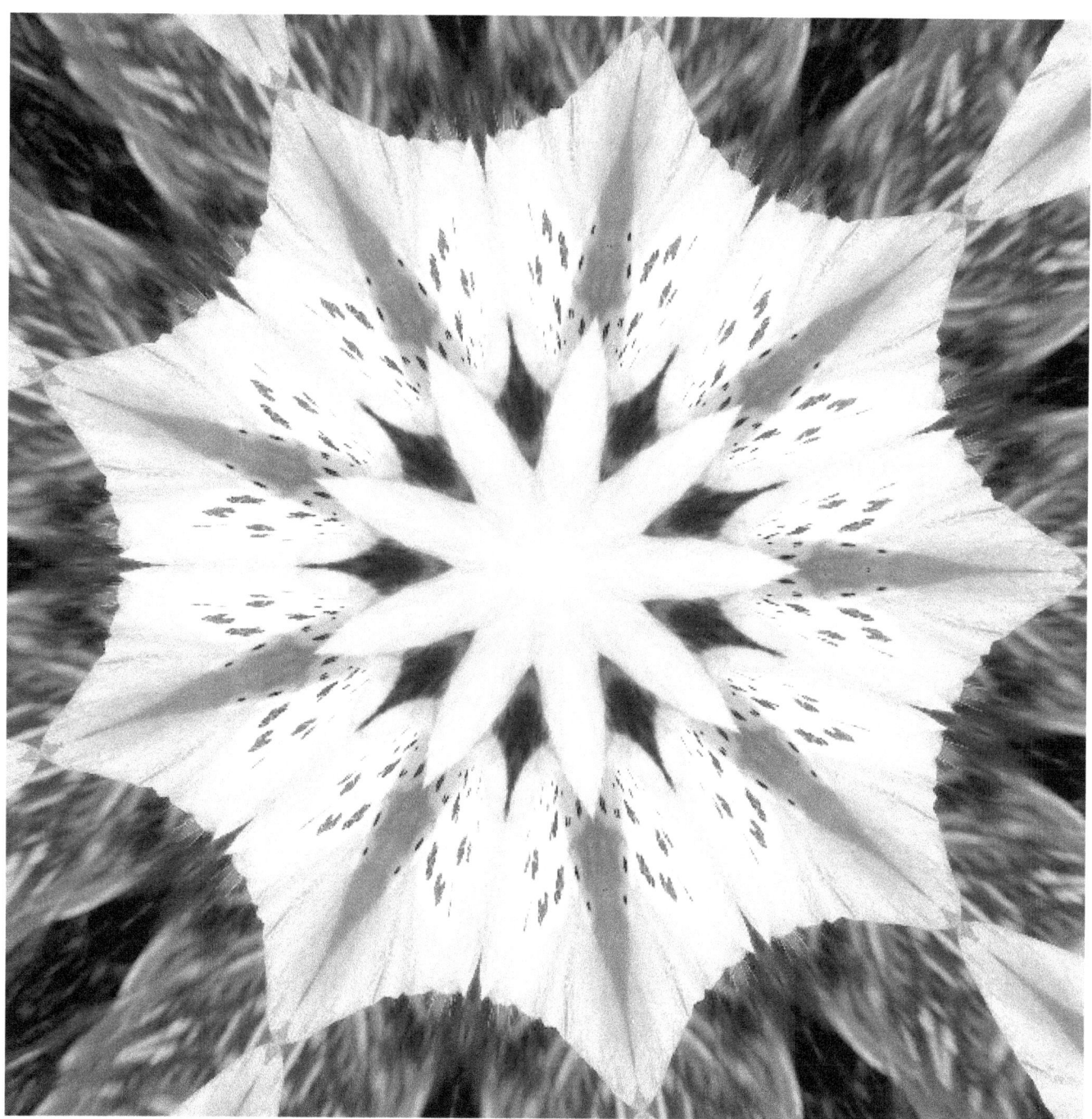

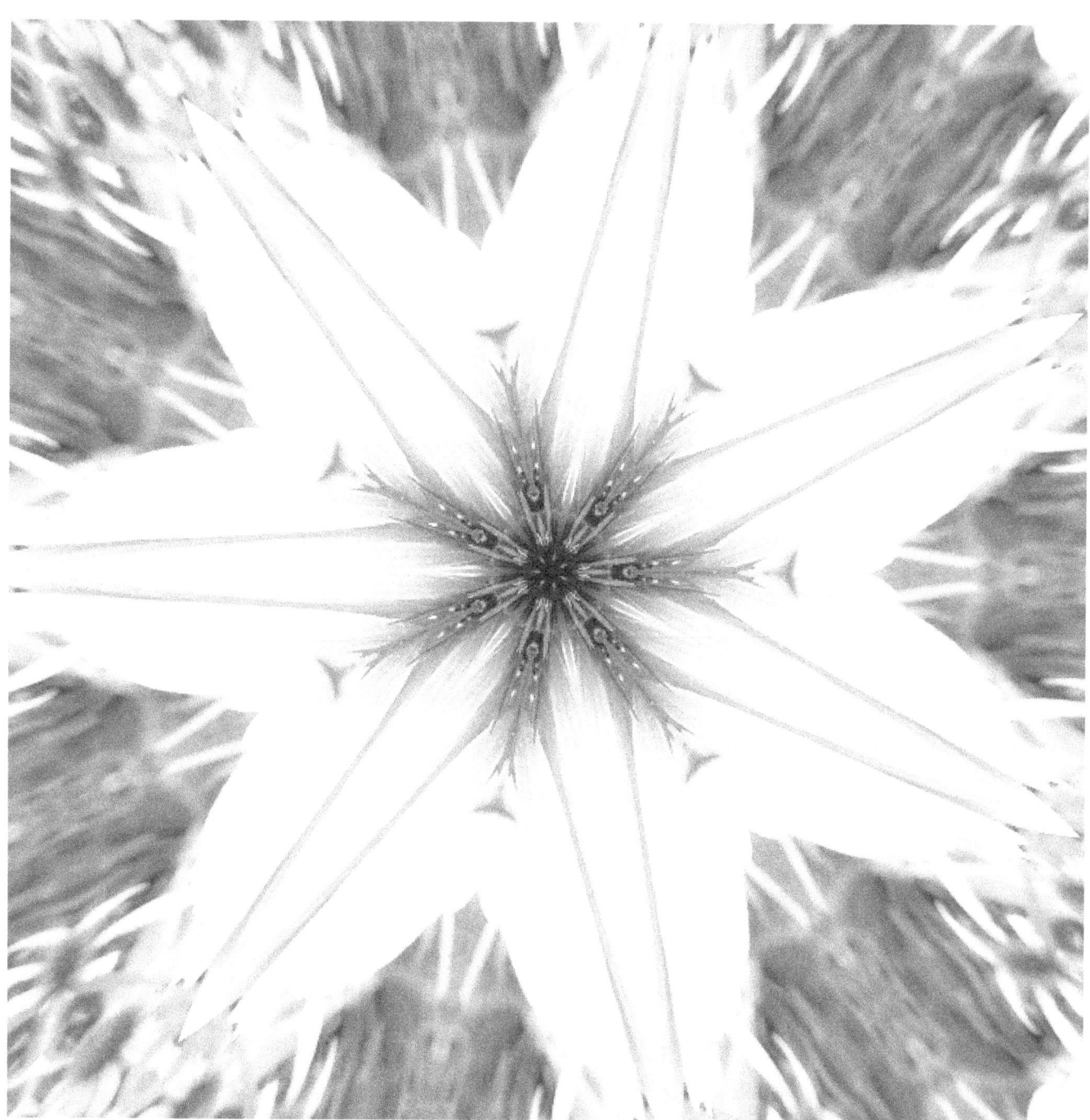

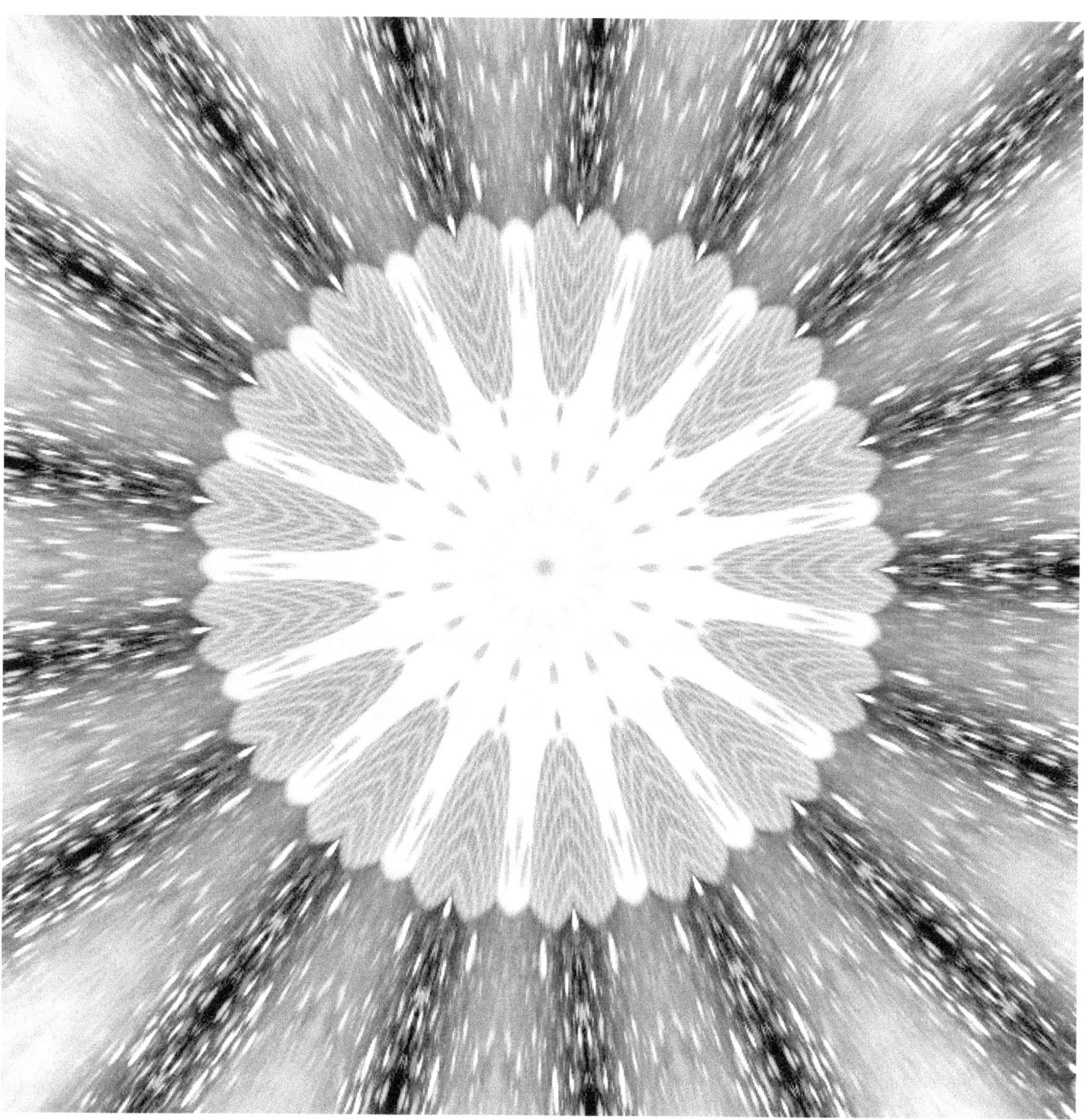

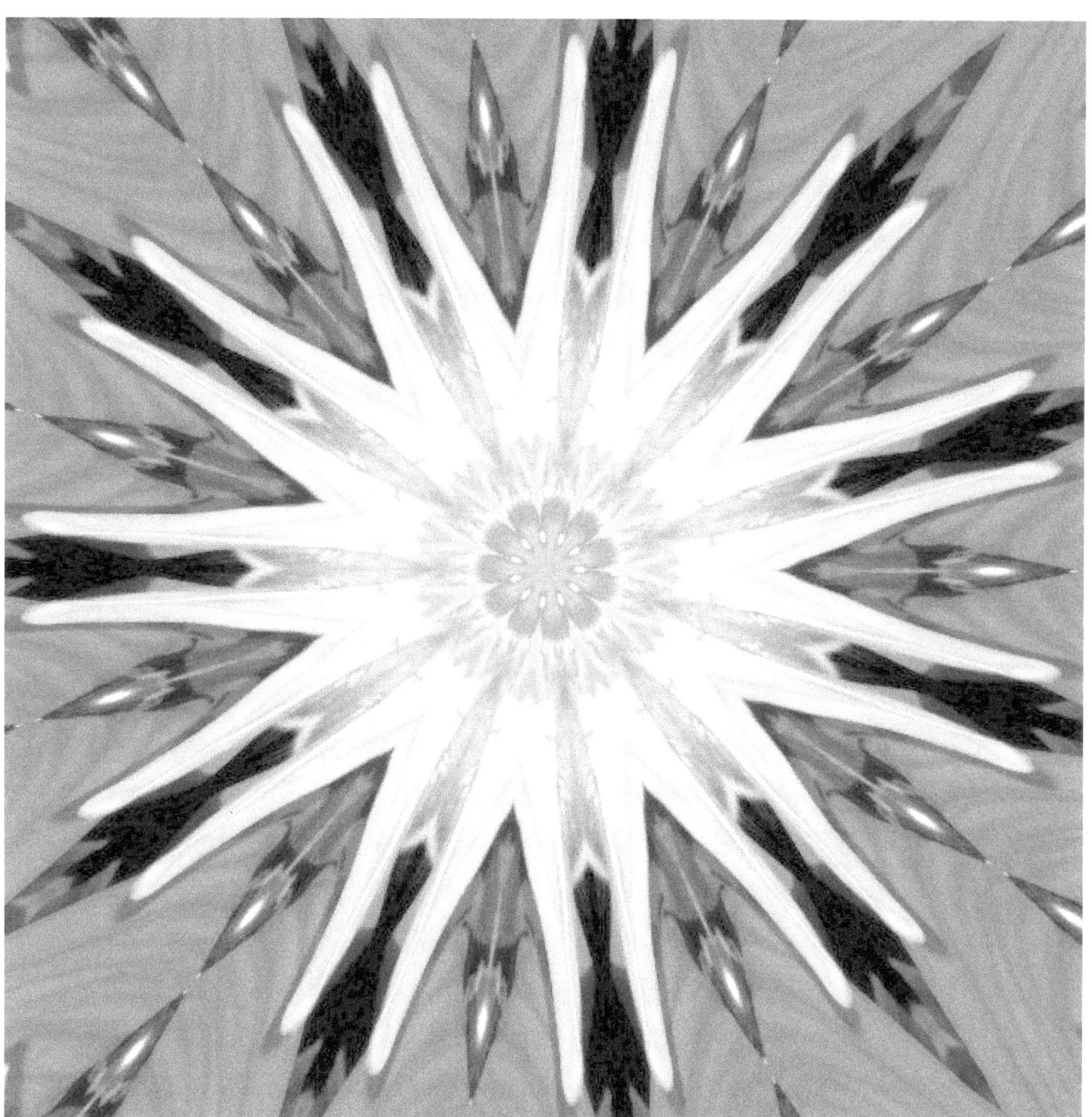

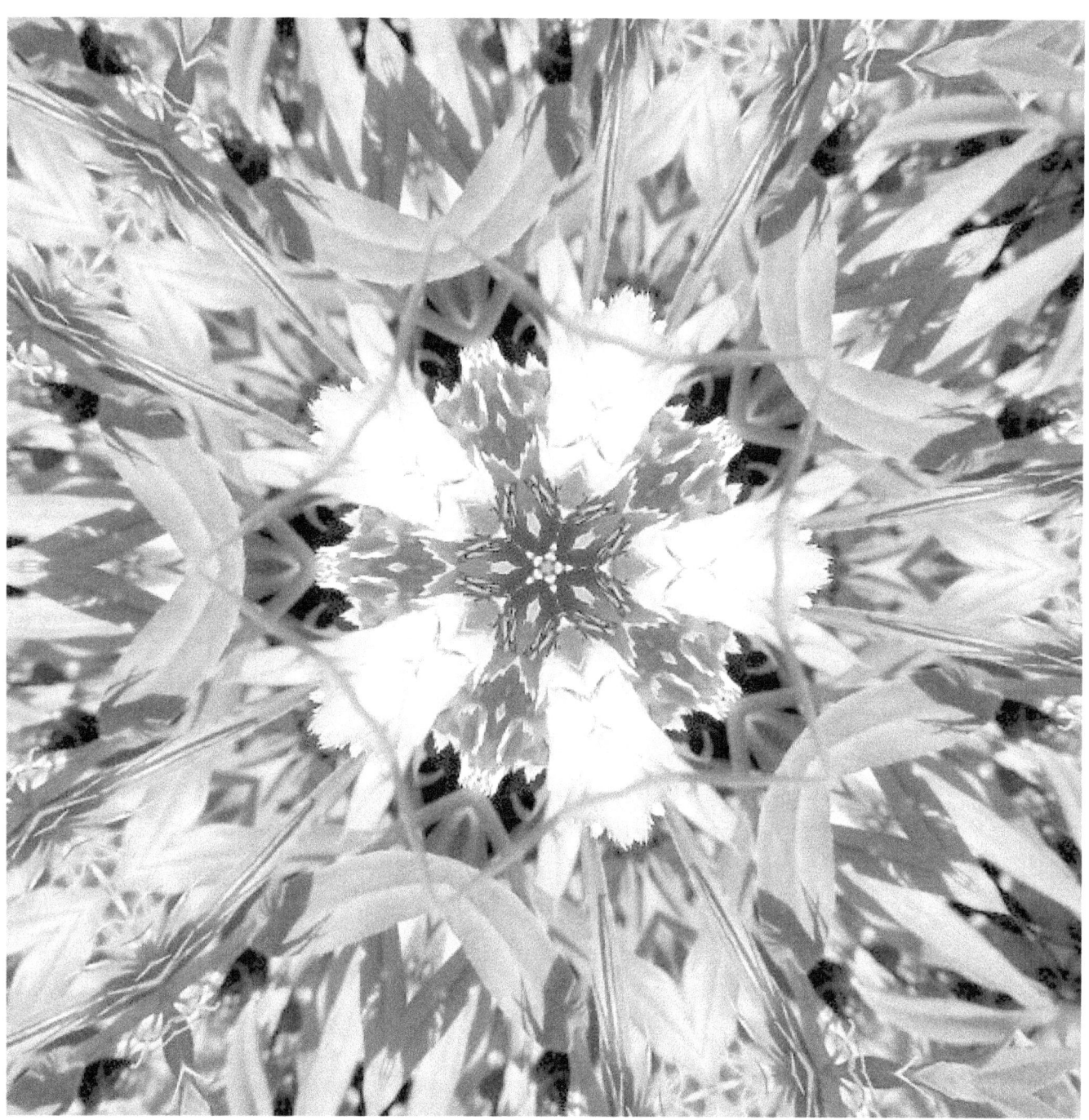

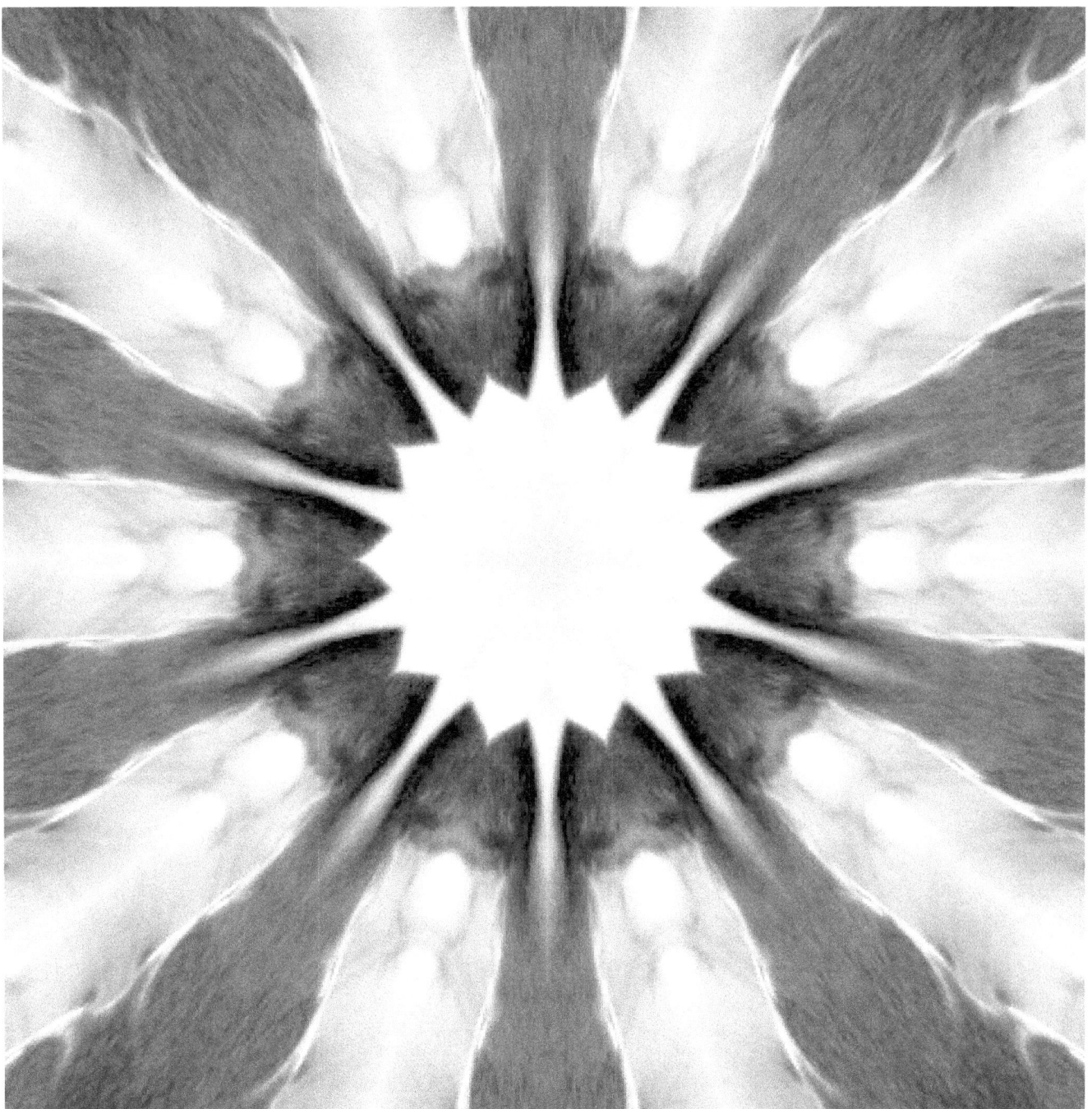

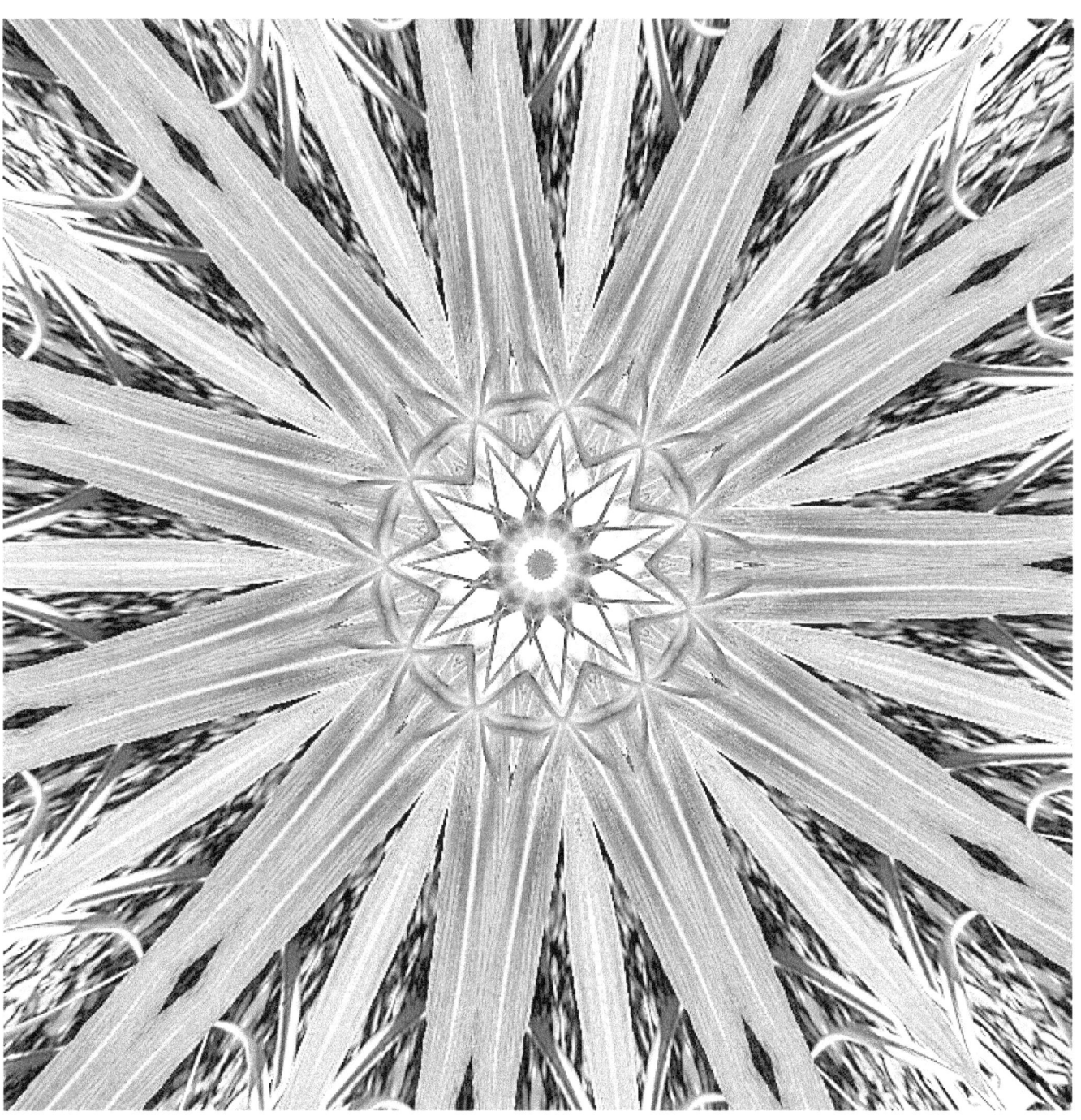

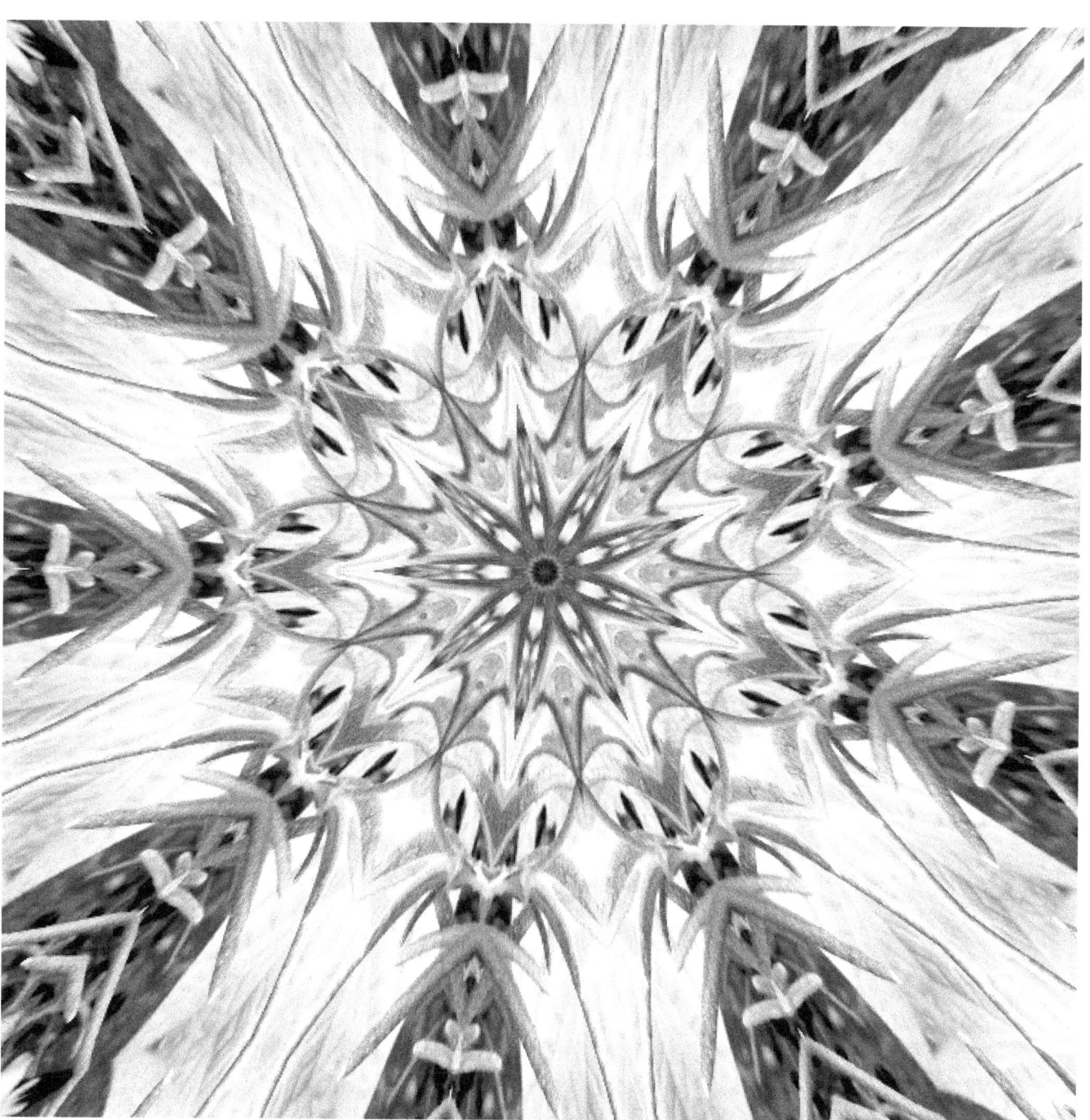

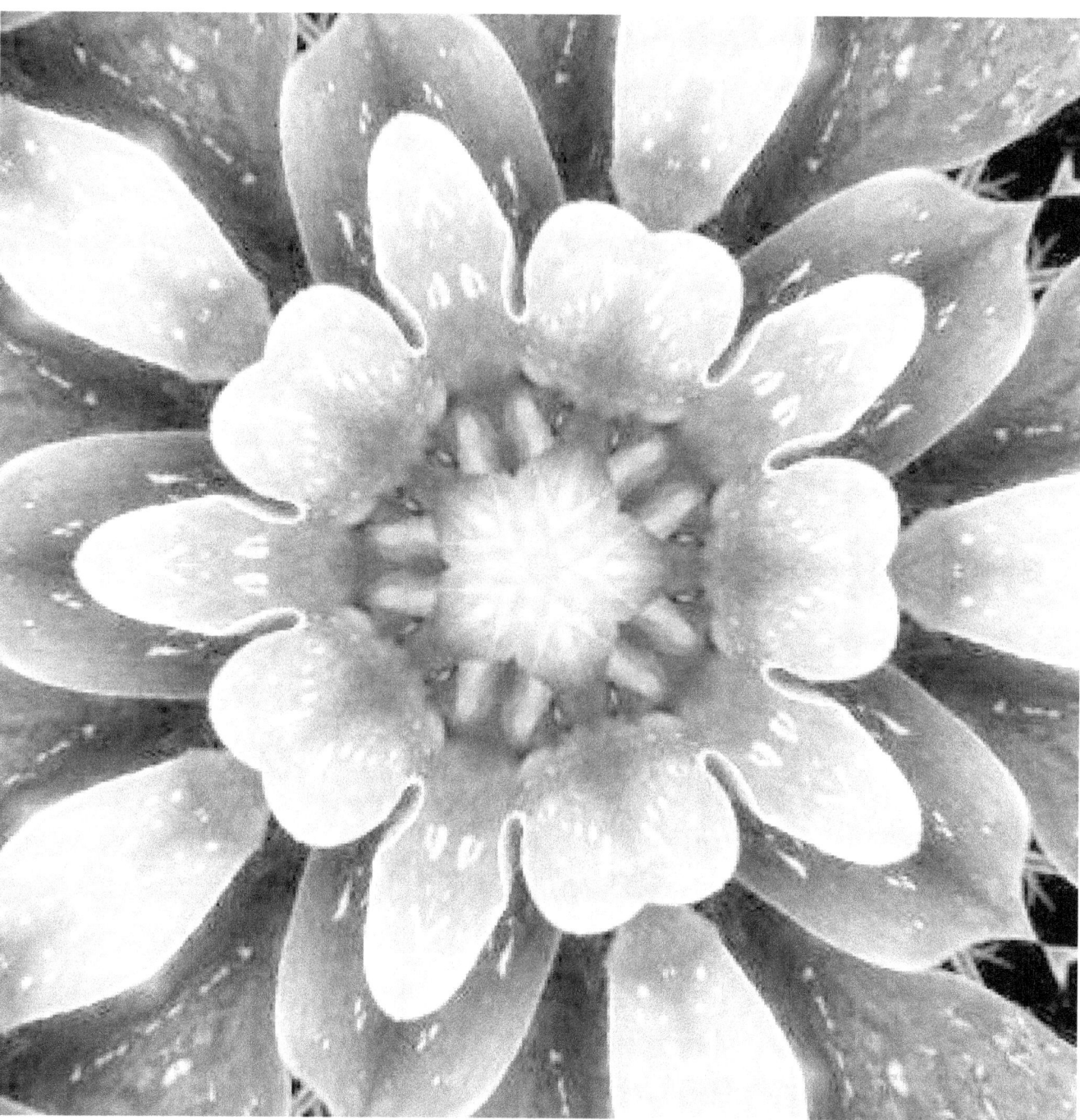

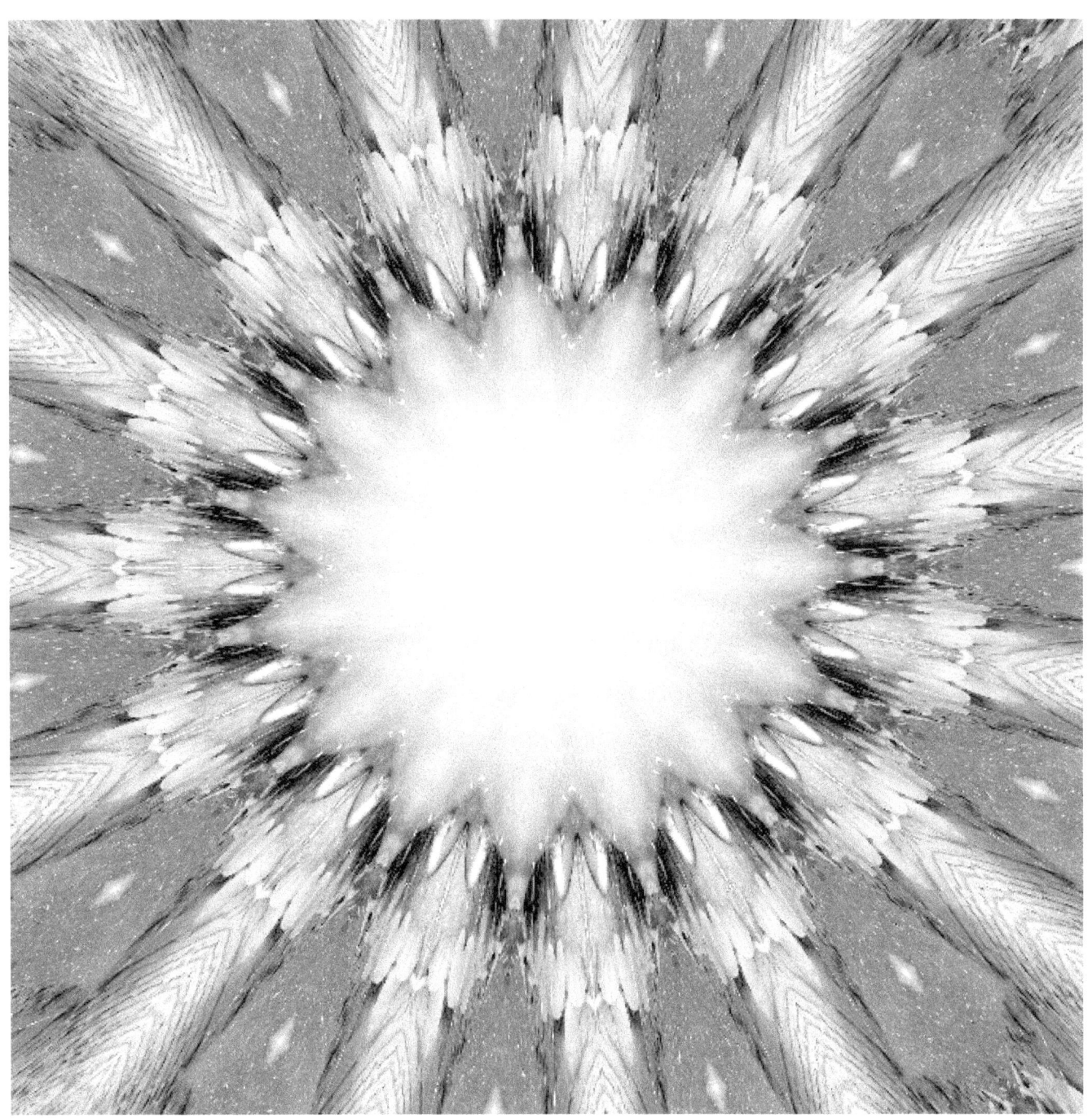

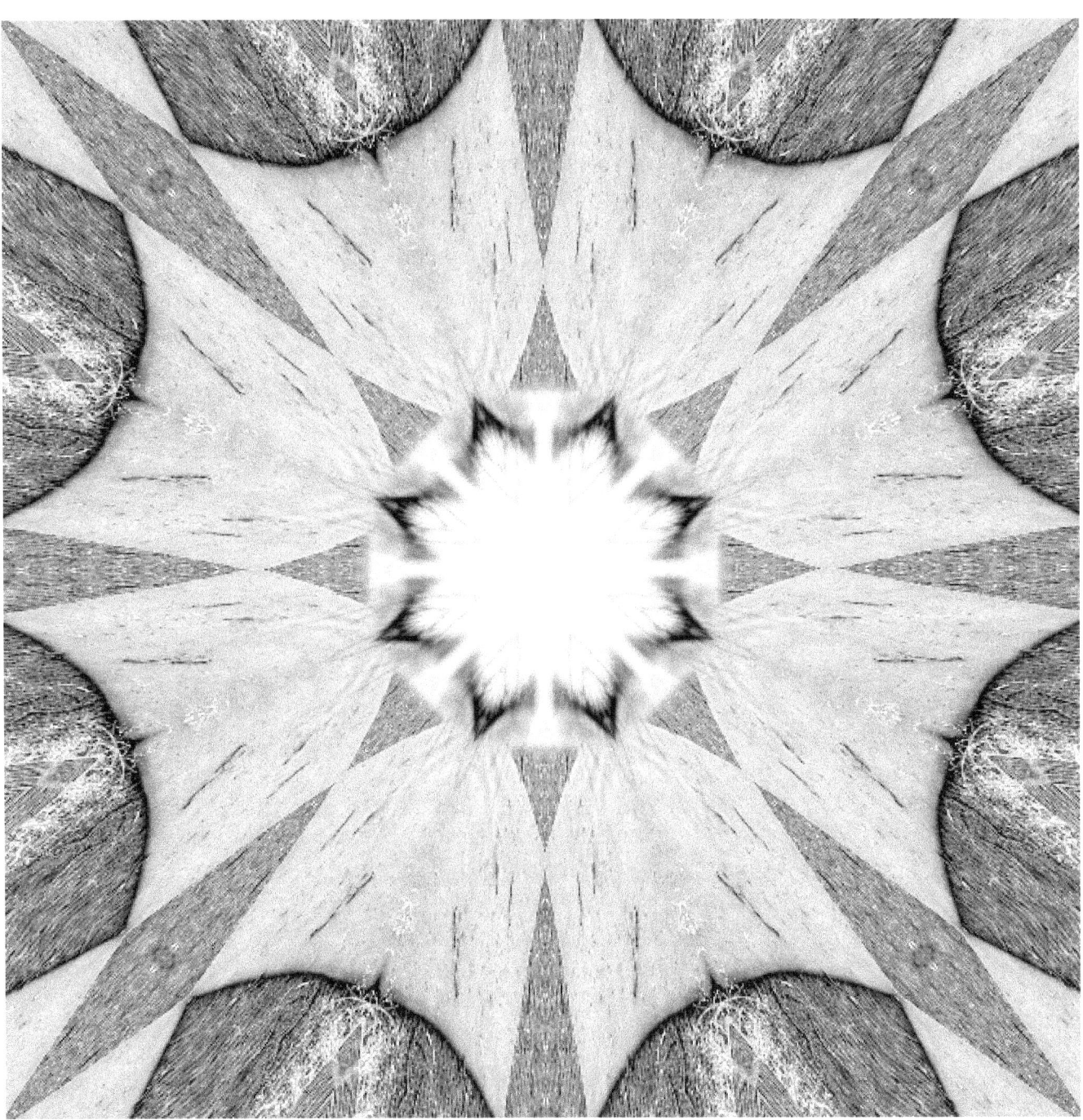

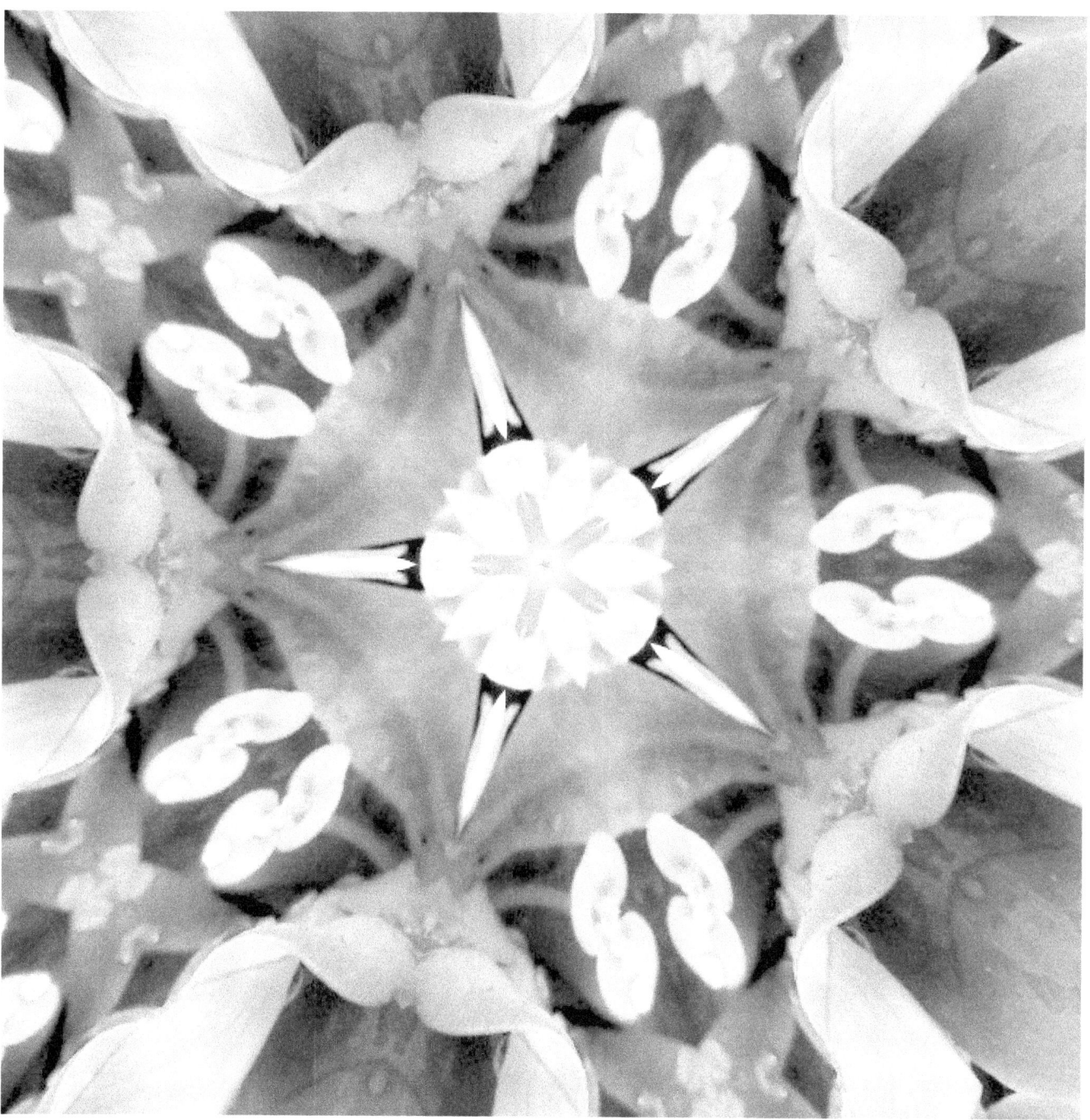

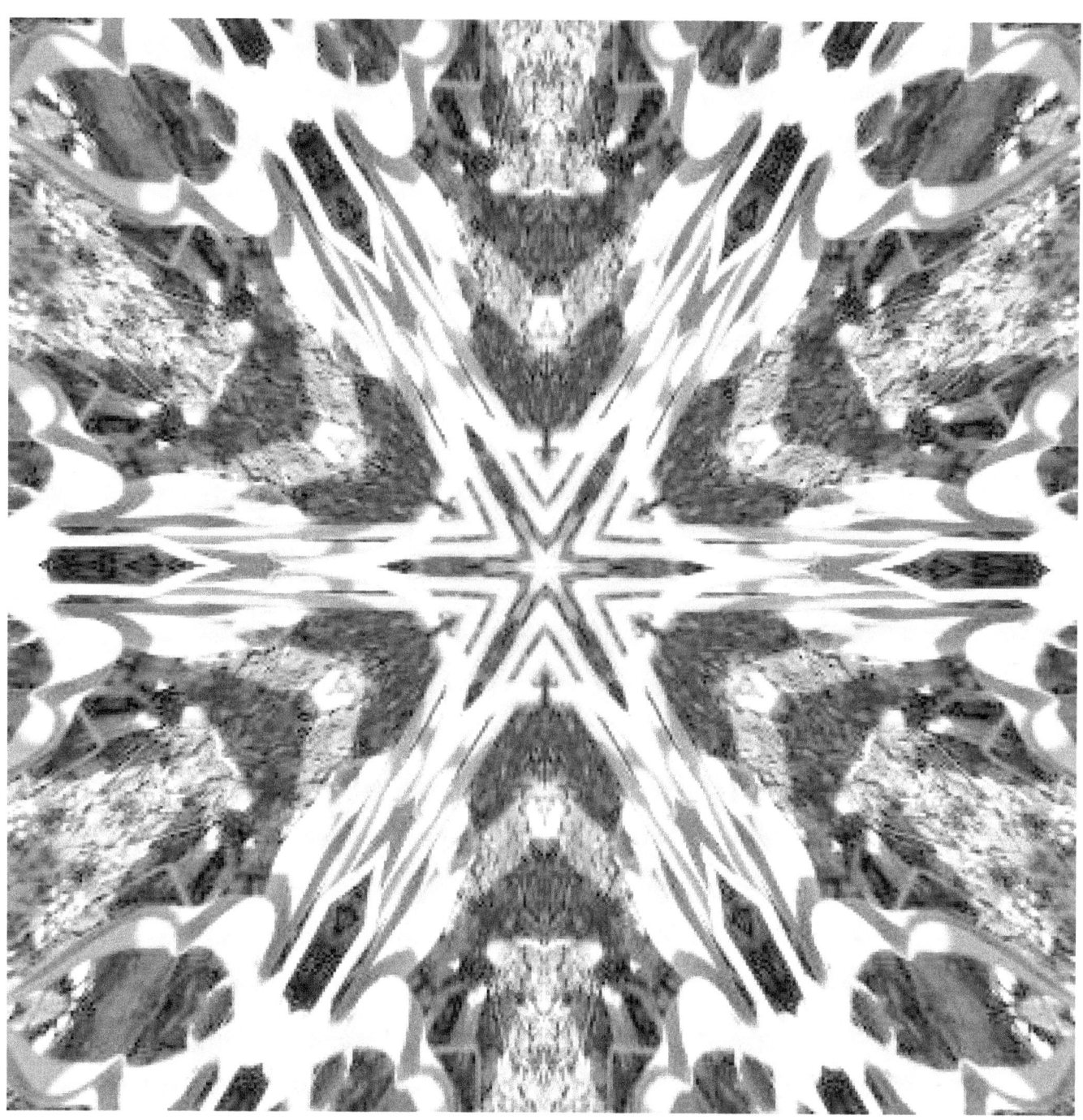

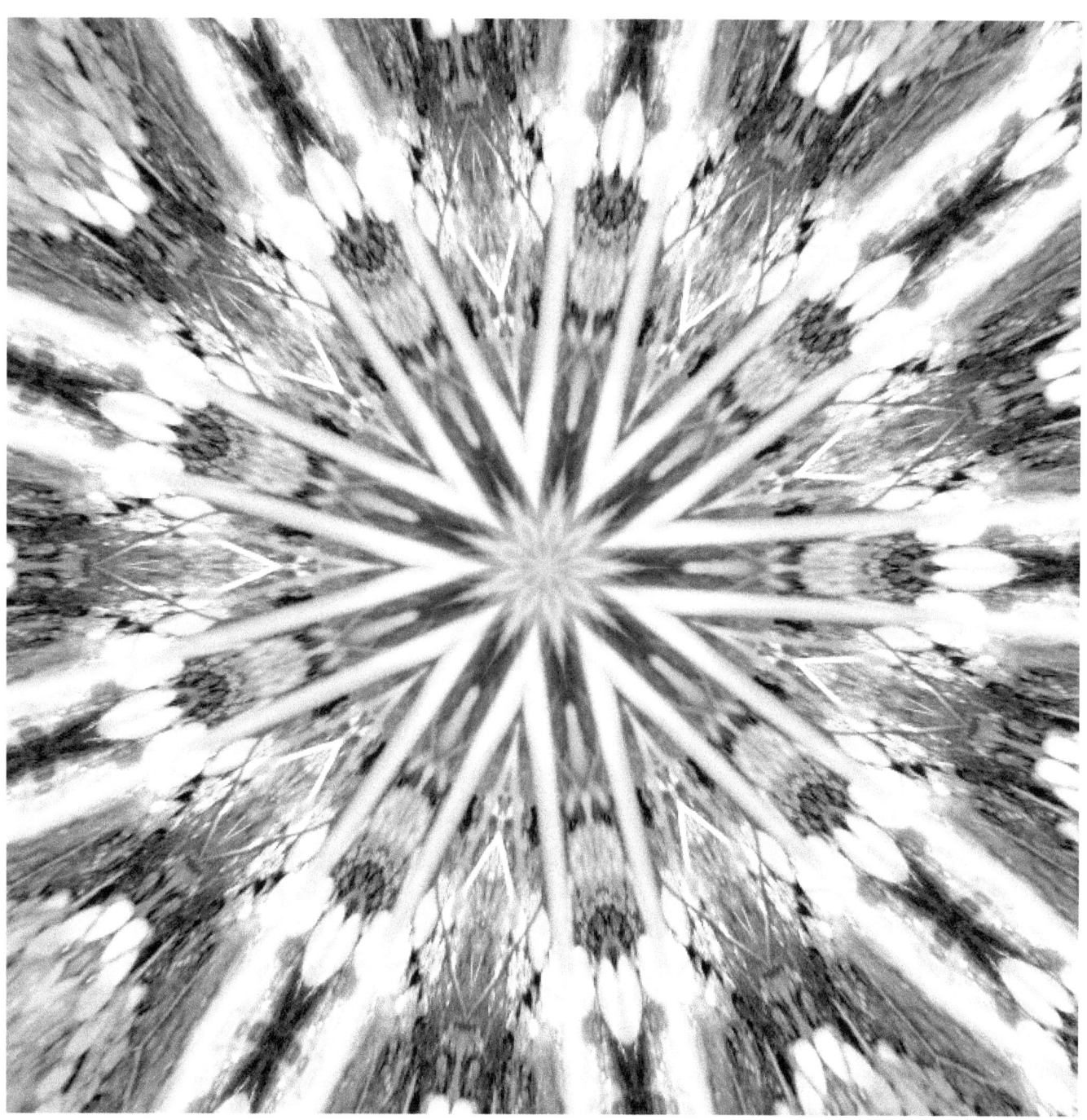

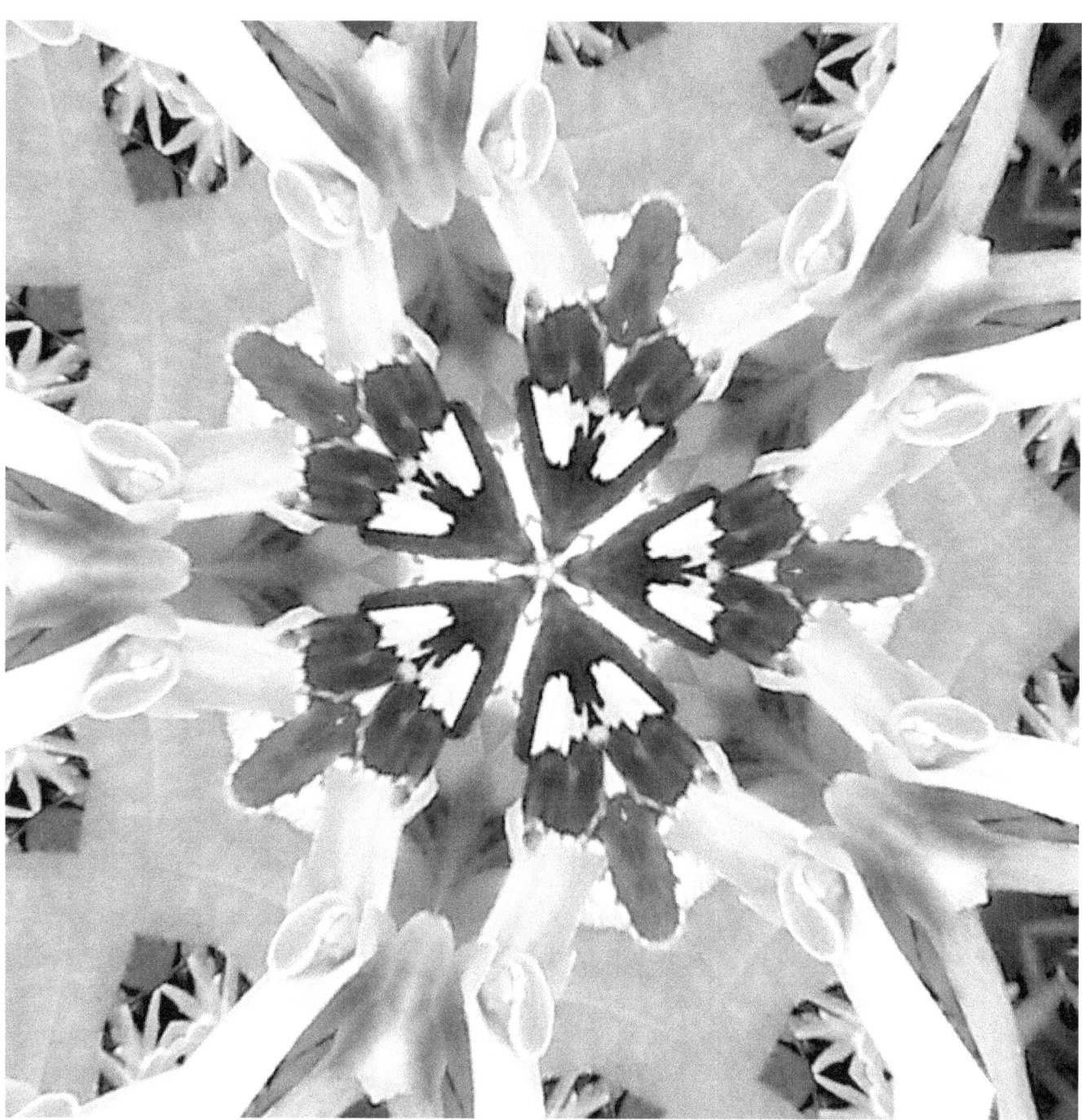

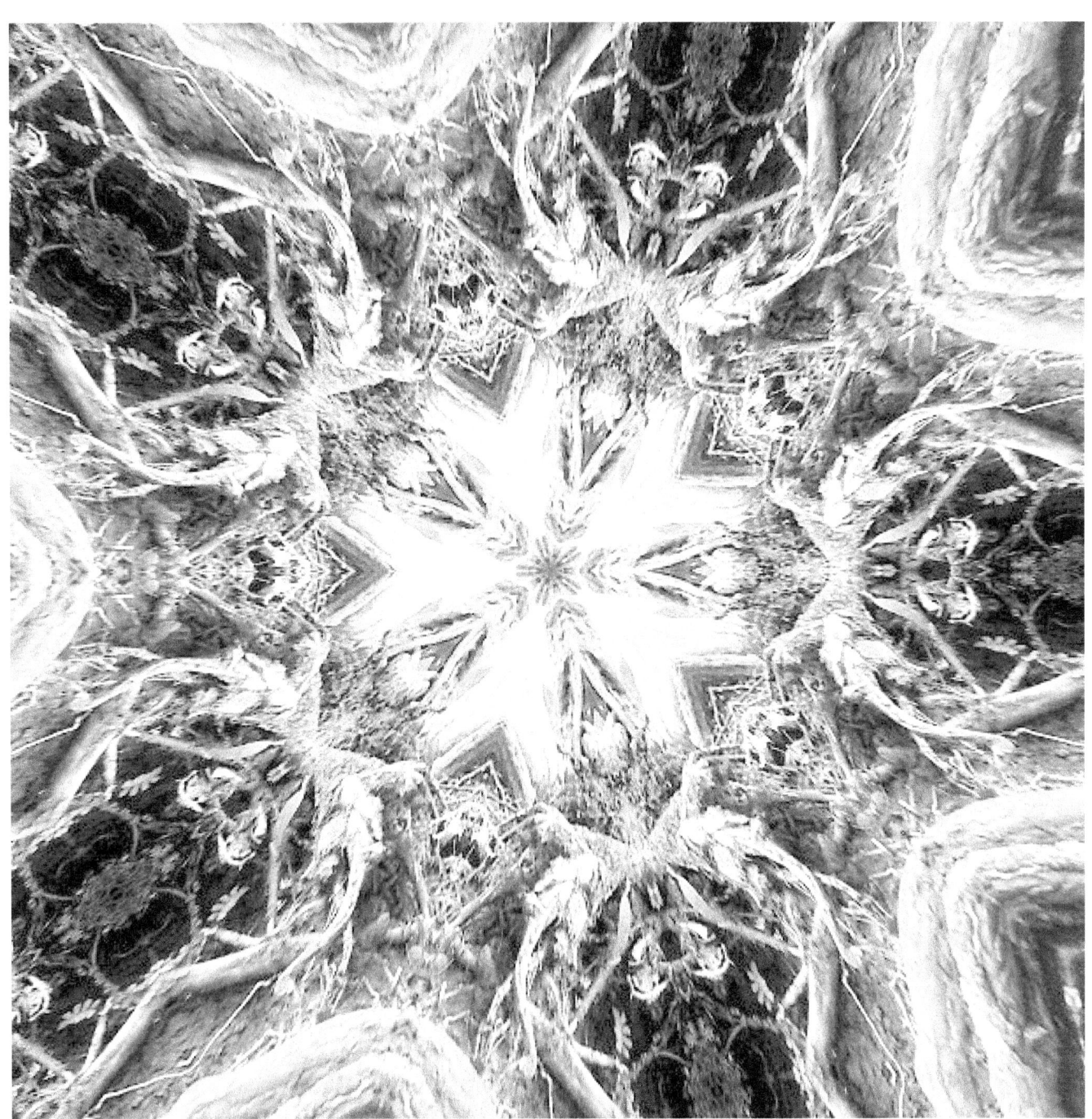

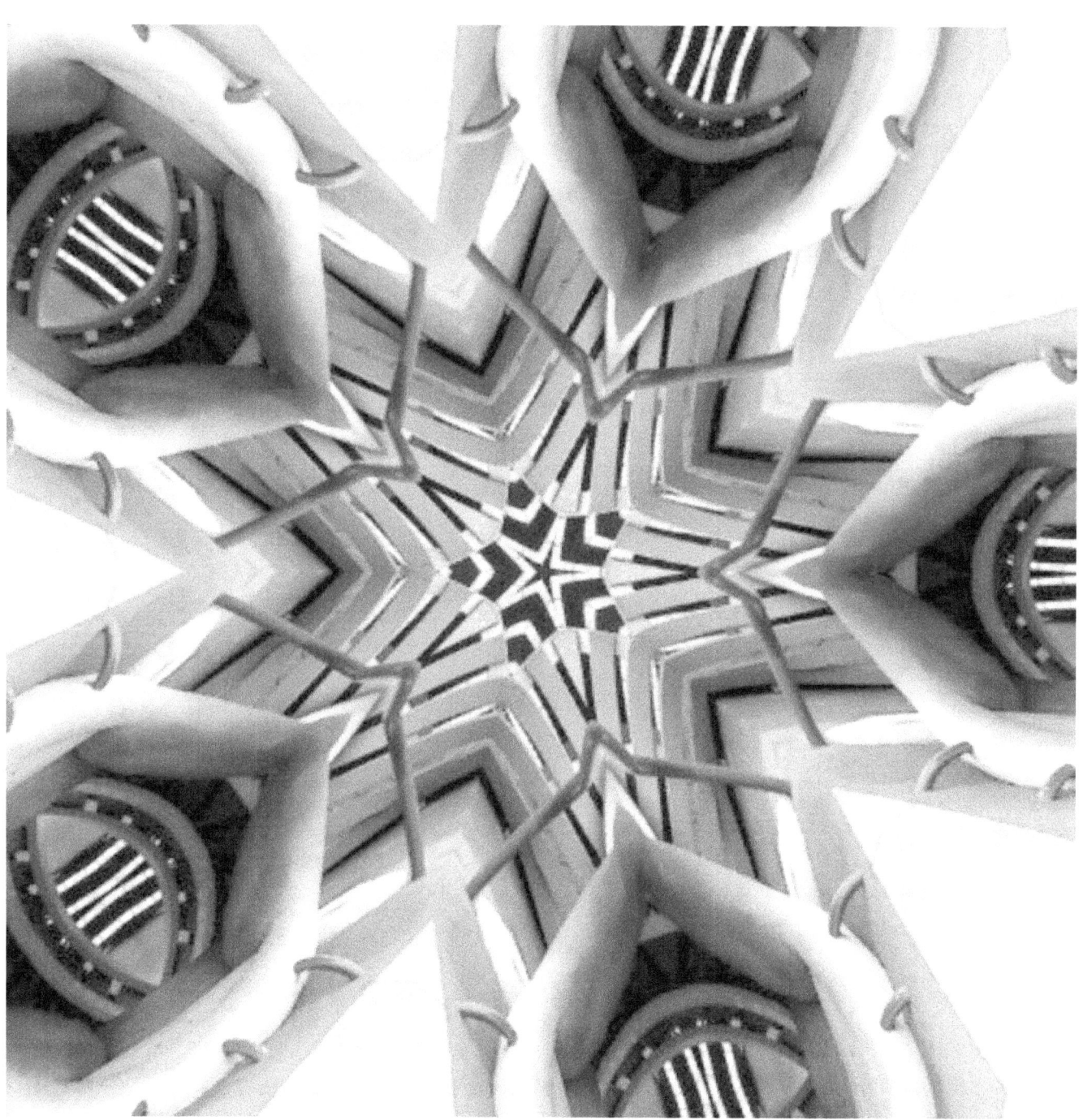

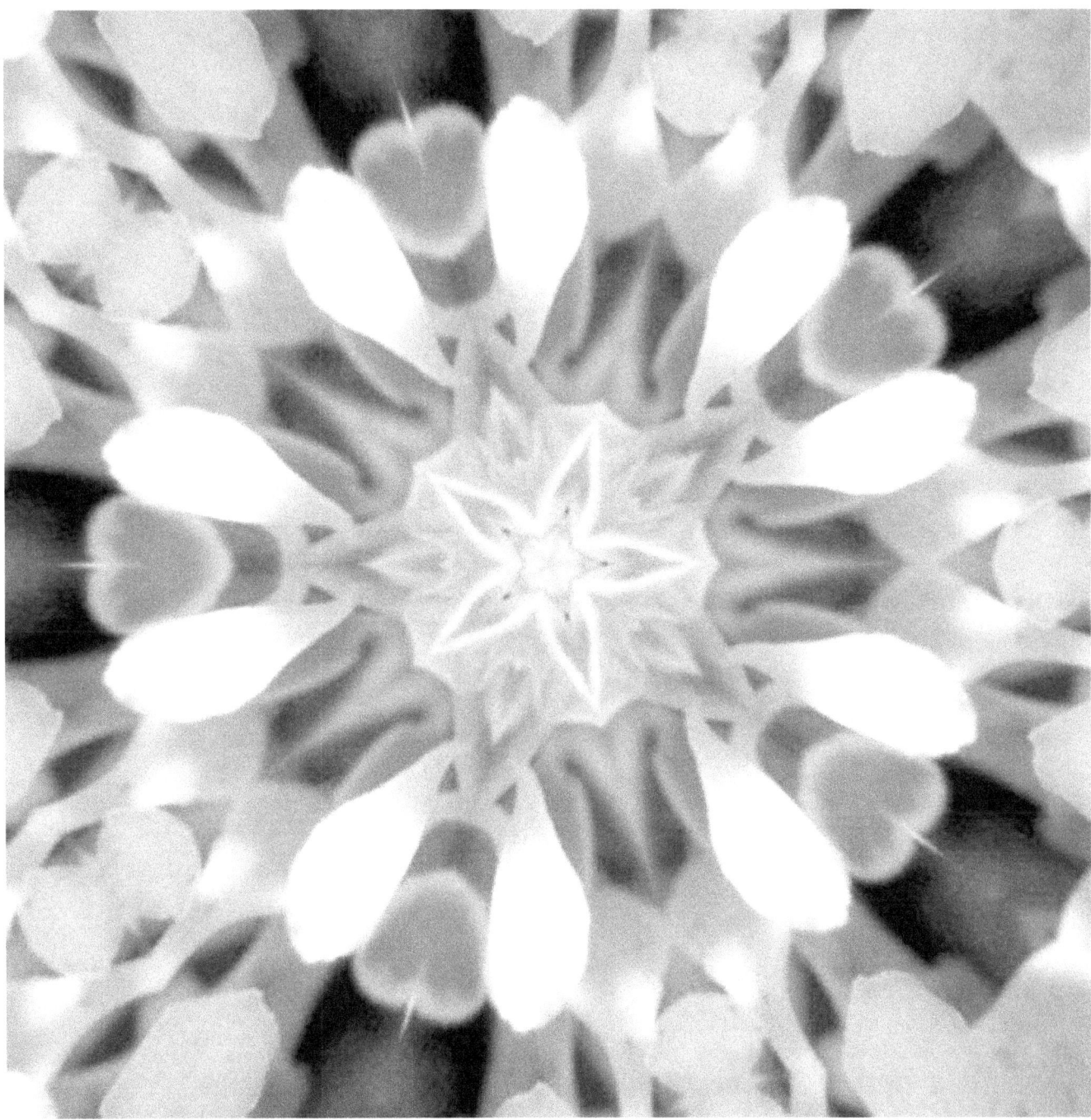

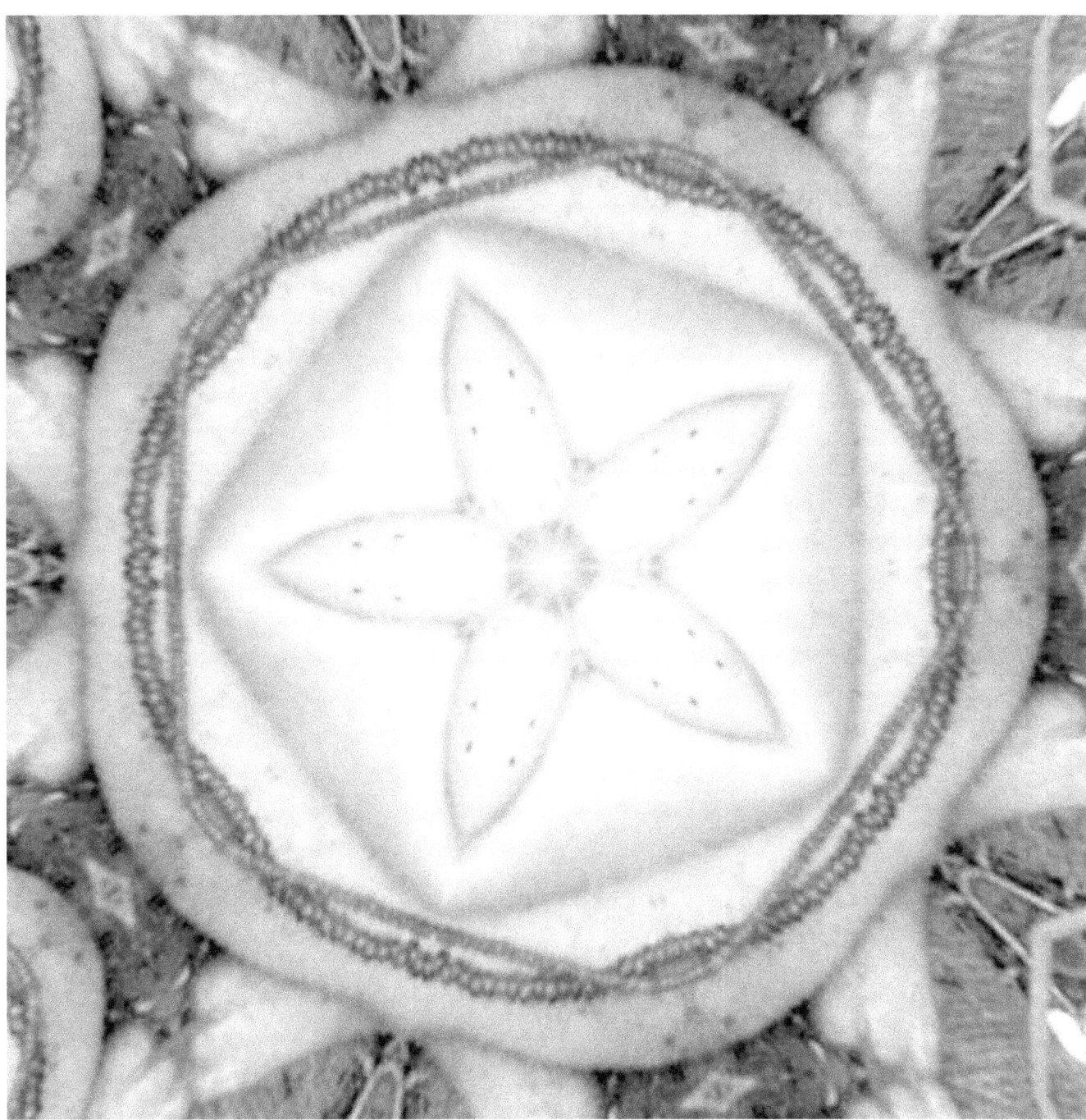

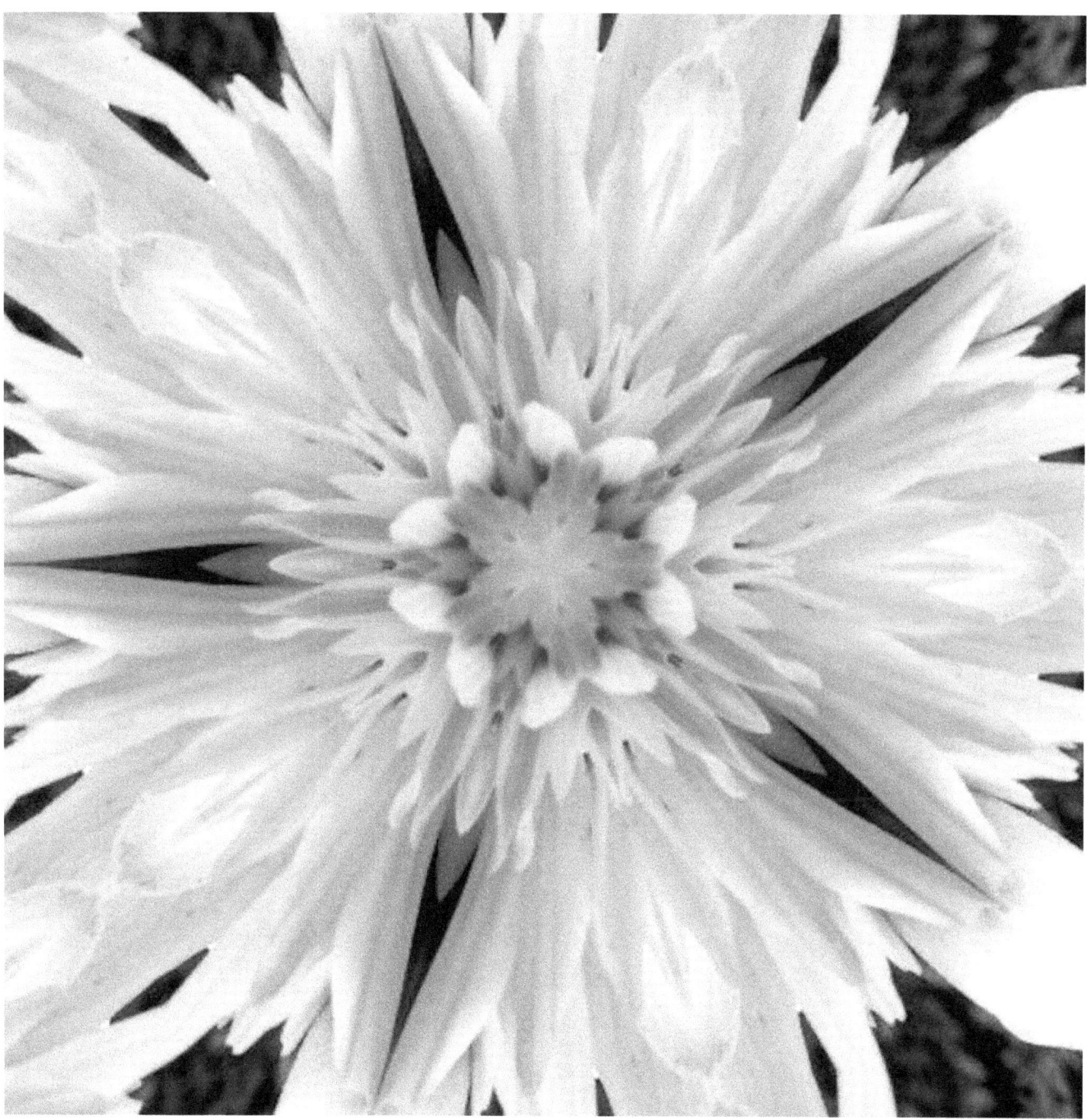

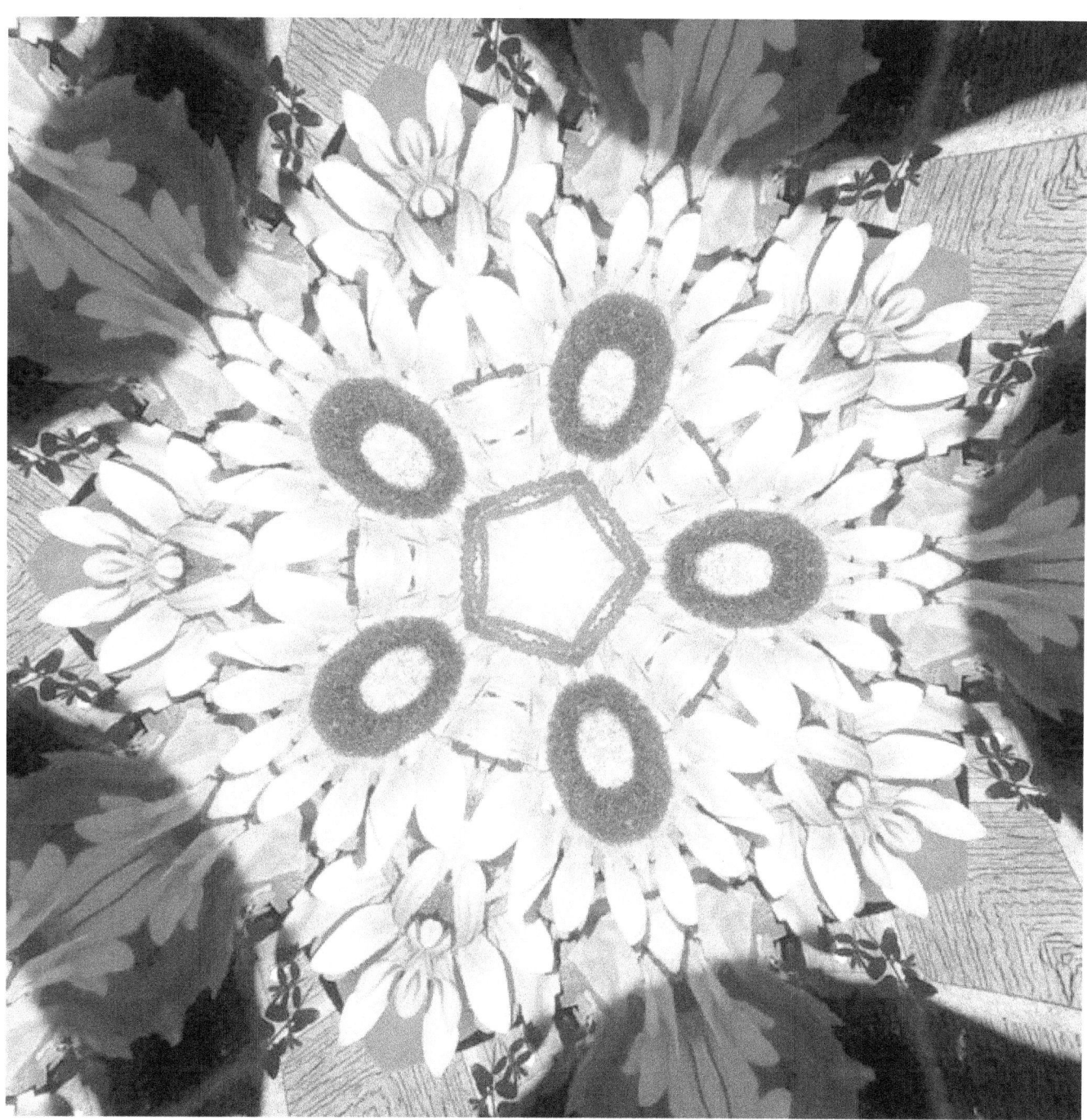

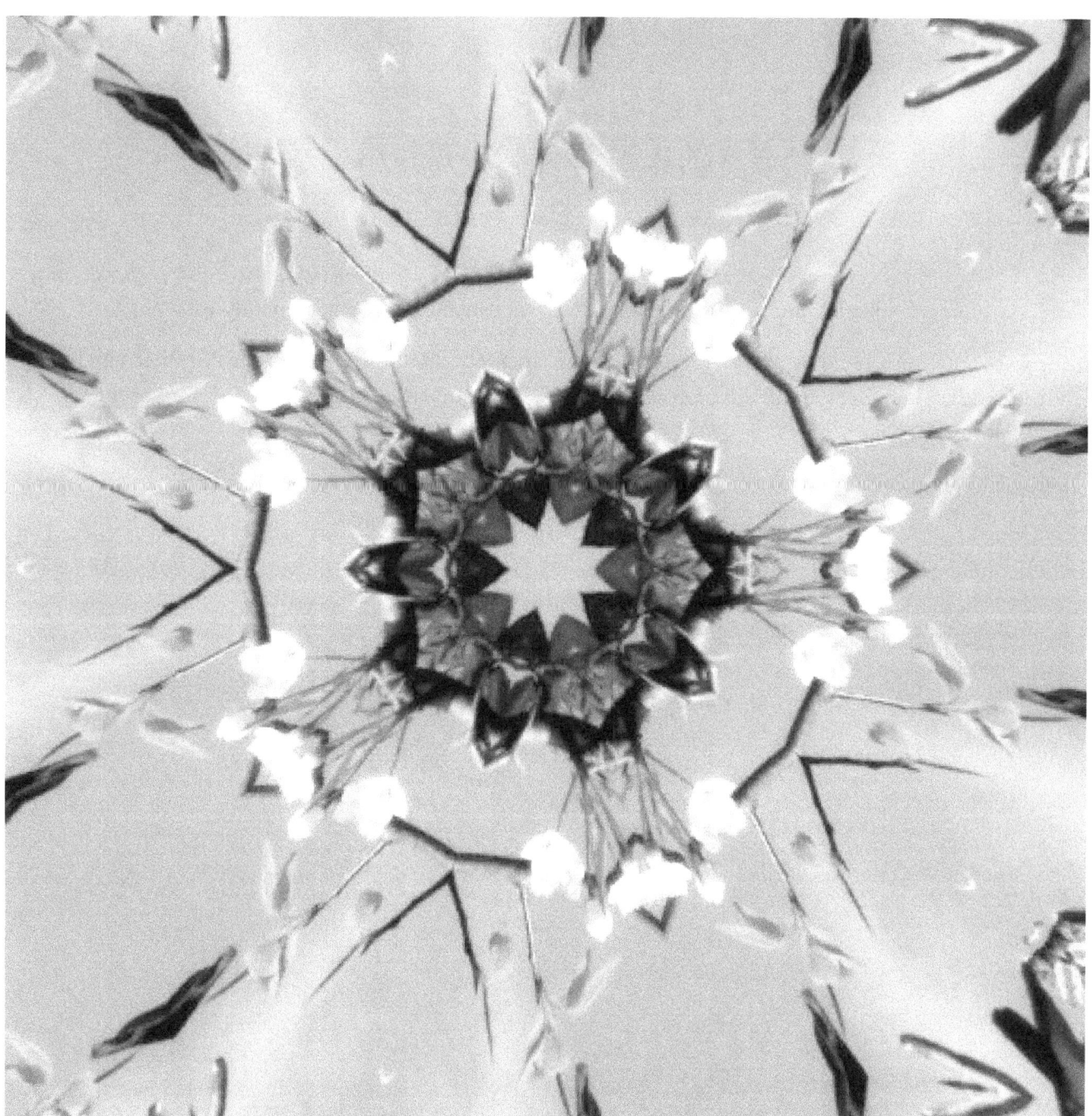

ABOUT THE AUTHOR

Erika grew up with sand and sun in her hair in Narragansett, RI. Ever the adventurer and all around tiny animal finder, her interest in the small details and the humble parts of nature took hold.

She was set up on a blind date at 17-years-old where she found her husband. They raised three children in Groton, CT where their home was surrounded with woods and streams which helped nurture their kids' interest in nature.

Erika's background includes working as a CNA, MA(AAMA), and as a medical transcriptionist - which she enjoyed until she was replaced by a dragon.

Her continued love of nature, gardens, Beale Street Music Festival and her pets compels her to take far too many photos, some of which she would like to share.

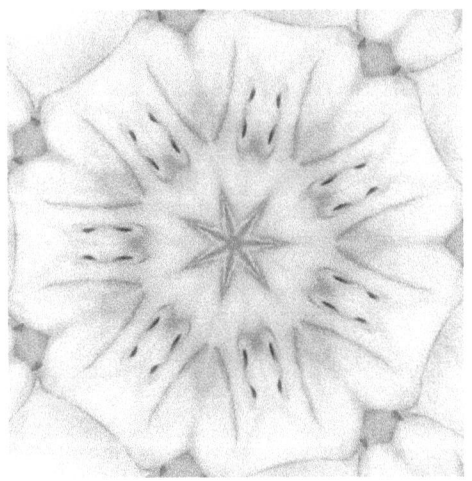

www.ingramcontent.com/pod-product-compliance
Lightning Source LLC
Chambersburg PA
CBHW080705190526
45169CB00006B/2248